UNI
MASSACHUSETTS AMHERST
ATHLETICS

May 2008

Jack,

Enjoy!

I was surprised
not to see "Groove More"
referenced as one of the
all-time great sports
played at UMass!

Best,

Doug Every '73, '76G

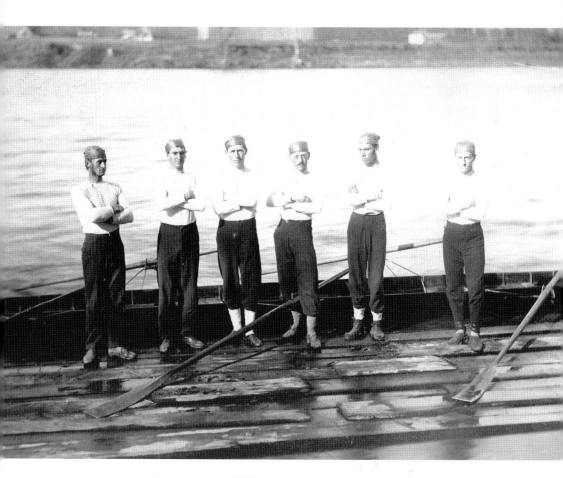

This Massachusetts Agricultural College crew team rowed past the Ivy Leaguers of Harvard and Brown Universities on July 21, 1871, at the Ingleside Regatta along the Connecticut River. The crew was Edward Hardy '72, Henry Simpson '72, George Leonard '71, Frederick Eldred '73, George Duncan '74, and Gideon Allen '71.

UNIVERSITY OF MASSACHUSETTS AMHERST ATHLETICS

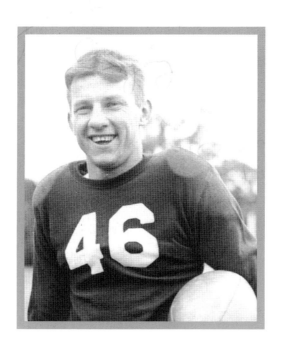

Steven R. Sullivan

ARCADIA

Published by Arcadia Publishing
Charleston SC, Chicago IL, Portsmouth NH, San Francisco CA

Printed in Great Britain

Library of Congress Catalog Card Number: 2005937956

For all general information contact Arcadia Publishing at:
Telephone 843-853-2070
Fax 843-853-0044
E-mail sales@arcadiapublishing.com
For customer service and orders:
Toll-Free 1-888-313-2665

Visit us on the Internet at www.arcadiapublishing.com

This book is dedicated to the twins, Alec and Eliza,

from the University of Massachusetts Amherst class of 2026.

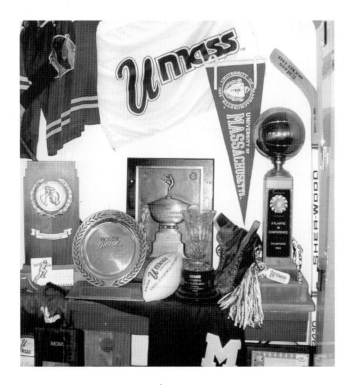

The Athletic Hall of Fame shrine is seen here, as displayed on the third floor of the Mullins Center.

CONTENTS

A MESSAGE FROM
THE CHANCELLOR

This book provides a remarkable view of the history of competitive athletics at the University of Massachusetts Amherst that began with our baseball team in 1868 and continues today with our 23 varsity sports for men and women.

Today's Minuteman commitment to a nationally competitive intercollegiate program builds on a history of achievement, emphasizing performance within a context of strong academics and a dedication to sportsmanship. We expect our student-athletes to excel on and off the field, and consider our intercollegiate athletic programs an integral part of the student experience. Intercollegiate sports provide participants and fans with a focus for their pride in the campus at Amherst and offer a visible symbol of the institution-wide commitment to high levels of achievement in the classroom, in research, and in public service.

Historians of this campus recount the pride of Pres. William S. Clark, who astride his horse on July 21, 1871, announced to the young Massachusetts Agricultural College campus that six students had just triumphed over both Harvard and Brown crews at the Ingleside Regatta. By 1924, Pres. Kenyon L. Butterfield could watch two of his hockey stars travel to the Olympic Games in Paris, France, to win a Silver Medal. In the mid-1960s, Pres. John W. Lederle spoke to the pep rally before students and fans boarded the bus to the institution's first ever postseason game at the Tangerine Bowl. In 2004, as this tradition of excellence continued, the chancellor had the honor of representing the campus at the 2004 induction of Elaine Sortino into the Softball Hall of Fame.

We offer this book as a testimony to the constant commitment to quality and nationally competitive performance that remain the defining characteristics of UMass Amherst intercollegiate athletics.

—Chancellor John V. Lombardi

Dr. John V. Lombardi, chancellor and professor of history at the University of Massachusetts Amherst, serves as coeditor of *The Center's Top American Research Universities* project on measuring university performance. Lombardi was dean of international programs and dean of arts and sciences at Indiana University, provost at Johns Hopkins University, and president of the University of Florida. He received his doctorate and master of arts degree from Columbia University, and his bachelor's degree from Pomona College.

FOREWORD

The UMass Amherst Alumni Association has a long tradition of supporting the university's athletic programs. From our early days as the Massachusetts Agricultural College Aggies to today's UMass Amherst Minutemen and Minutewomen, the alumni association has been there to cheer our players on. At each event, alumni bring school spirit, high hopes, and the desire to see student-athletes excel.

The UMass Amherst Alumni Association coordinates a wide variety of sports-related gatherings each year to engage alumni throughout the world and to further cultivate their loyalty to the university. Alumni clubs host game-watching events around the country, and Meet the Coach receptions introduce alumni to new coaching staff and allow them to regale over upcoming sport seasons. And of course, the Alumni Tent at MinuteFan Park is a perennial favorite among football fans. Good food and good friends always make for the perfect pregame festivities.

Sponsorships and grants from the alumni association have supported a number of initiatives that have advanced the athletics program and strengthened its brand image. The UMass Amherst cheerleading team attended the National Cheerleading/Dance Collegiate championships, the football team purchased laptop computers for use by the players during away games, and the women's ice hockey team put on a White Out-UMass Tournament, to name a few of the sponsored activities.

Beyond rallying for our alma mater and providing financial assistance, the alumni association also supports the valuable life lessons that go hand in hand with the UMass Amherst athletics program. Students learn self-discipline, self-understanding, teamwork, sportsmanship, and integrity. They are encouraged to develop their skills as competitors, students, and members of the greater community. By allowing each student to develop to his or her fullest potential, athletics enhance the exceptional educational experience offered at UMass Amherst.

The UMass Amherst Alumni Association is proud of its affiliation with the university's athletics program. We encourage alumni to continue their support of athletics and the university as a whole by joining with us as a member of the alumni association. Your membership helps to foster programs and to enrich the UMass Amherst experience. We look forward to many more years of exciting competition and play. Go UMass!

<div align="right">

—Hal Lane Jr. '60
UMass Amherst Alumni Association President

</div>

Hal Lane Jr. '60 is president of the UMass Amherst Alumni Association.

INTRODUCTION

This book is a fabulous journey through the history of University of Massachusetts Amherst athletics. In 1868, the Massachusetts Agricultural College Aggies baseball team was born. In 1878, the Aggies first football team was assembled, and over the next 125 years, the college expanded its varsity sports programs to 23.

The earliest intercollegiate sports at Massachusetts Agricultural College (MAC) were crew, baseball, football, and the rifle team. All of these teams competed against other colleges in New England. No result was more memorable than the upset victory at the intercollegiate regatta of July 21, 1871, held for the first time at Ingleside on the Connecticut River. The farmers of Massachusetts Agricultural College beat Ivy League powerhouses Harvard and Brown Universities. The "farmers" beat the "brains" of second-place Harvard by 14 boat lengths (approximately 700 feet). The victory at Ingleside brought enormous notoriety to the infant college in Amherst and brought regional and national attention to the college, showing it to be a fine developer of young manhood. The victory also showed many smaller institutions that they, too, could play the big schools and win, thus stimulating the smaller schools to form teams.

And form teams we did. Our 1914 baseball team produced three major-league baseball players: Lloyd "Chick" Davies, Lee King, and Joel Sherman. Our 1921 men's hockey team produced two silver medalists at the 1924 Olympic Games in Paris, France: Jerry McCarthy and John "Sharky" Lyons. On April 21, 1973, in Des Moines, Iowa, the UMass women's gymnastics team captured its first ever AIAW intercollegiate gymnastics national championship title. The 1982 UMass women's lacrosse team finished the season with an undefeated 10-0 record, and the first ever NCAA women's lacrosse national championship. Tammy Marshall became UMass's first NCAA champion in women's gymnastics when she captured the 1992 NCAA title on vault with a score of 9.8125. In 1998, the football team won the Division I-AA national championship by defeating an undefeated Georgia Southern team by a score of 55-43.

At the 2000 Olympic Games in Sydney, Australia, the world saw UMass pitcher Danielle Henderson accept a gold medal in women's softball.

Our sports programs, in their 135th year of existence, have produced some of the most recognized student-athletes in sports history. The university remains committed to its teams and the excitement they bring to our campus.

—John McCutcheon
Athletic Director

John McCutcheon, the sixth permanent athletic director in school history, came to UMass from California Polytechnic State University in San Luis Obispo, where he was the director of athletics for a 20-sport varsity program from 1992 to 2004.

Massachusetts Agricultural College Aggies

1863–1931

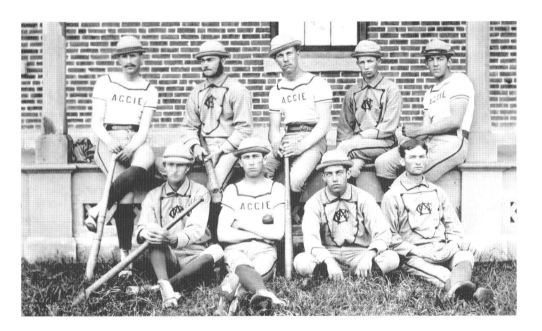

The first baseball team at Massachusetts Agricultural College (MAC) was organized in 1868, the first spring following the entrance of the pioneer class, in 1867. Due to the vision of Lewis A. Nichols '71, who organized it, and the generosity of trustee honorable Marshall P. Wilder, who financed it, the MAC baseball team was duly named the Wilder Nine. (Courtesy of Special Collections and University Archives, W. E. B. Du Bois Library.)

The catcher shown here is catching a ball thrown by the pitcher while the fans stand unusually close to the foul line. Since the inception of the Wilder Nine, it took almost 10 years to field a consistent team and secure transportation to and from their opponents' ballparks. In 1887, uniforms and gloves were bought and the name changed to the Aggie Nine. (Courtesy of Special Collections and University Archives, W .E. B. Du Bois Library.)

With a backstop to protect North Dormitory, players catch and hit at batting practice. In the early days, to make the game interesting, the batter was allowed nine balls. The ball was larger and softer than contemporary baseballs. The first uniforms had the letters MAC across the front and were laced up at the neck. (Courtesy of Special Collections and University Archives, W. E. B. Du Bois Library.)

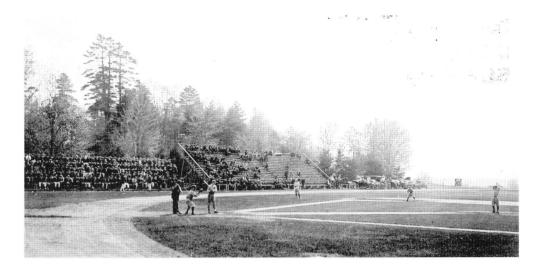

Notice the cars parked at the end of the bleachers. This picture shows a MAC baseball game (around 1914) at an unidentified ball field. With the advent of the new century, better transportation widened the field of competition, and the Aggie Nine added Maine State College, Williston Academy, Trinity College, Vermont Academy, Mount Herman, Bates, and Colby to its schedule. (Courtesy of Special Collections and University Archives, W. E. B. Du Bois Library.)

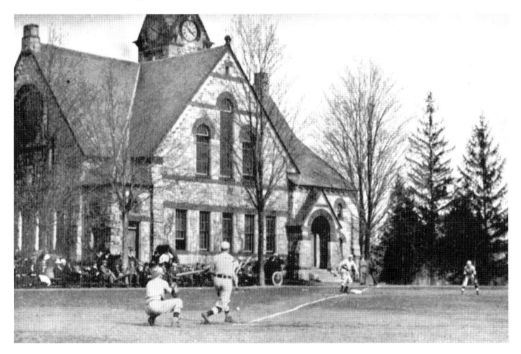

In 1915, the MAC baseball team played in close proximity to the Old Chapel. (Courtesy of Special Collections and University Archives, W. E. B. Du Bois Library.)

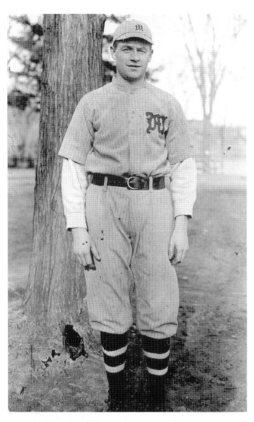

An unidentified ballplayer is shown here in a vintage 1914 baseball uniform. During a ball game in 1899, Aggie player Orrin Fulton Cooley of South Deerfield figured in a unique umpire's decision. He was playing outfield and, while running after a fly ball, his belt became loosened and his pants opened at the waist. The descending ball missed his glove, bounced off his stomach, and went down his pants. Was the batter out or not? The umpire said yes. (Courtesy of Special Collections and University Archives, W. E. B. Du Bois Library.)

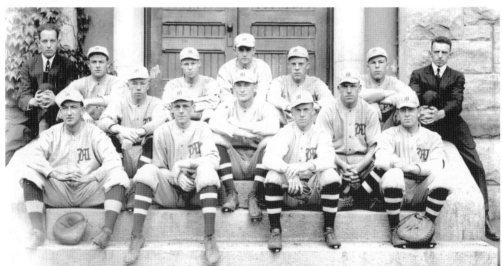

Shown here is the 1914 MAC baseball team. This team produced three major-league baseball players: Lloyd Garrison "Chick" Davies '14 (first row, third from the left), Joel Powers Sherman '14 (second row, center), and Edward Lee King '16 (third row, third from the left). (Courtesy of Special Collections and University Archives, W. E. B. Du Bois Library.)

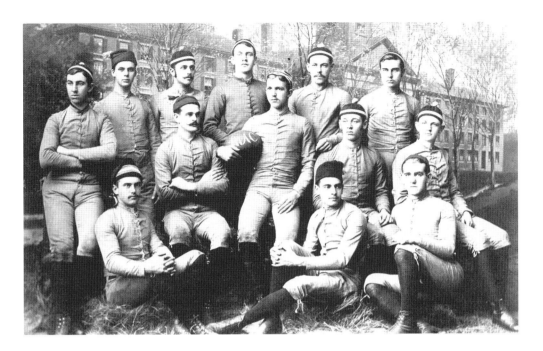

Football started on the Massachusetts Agricultural College campus in 1878. Francis Codman '80 and J. J. Delano '82 were the principals in organizing the first MAC team. (Courtesy of Special Collections and University Archives, W. E. B. Du Bois Library.)

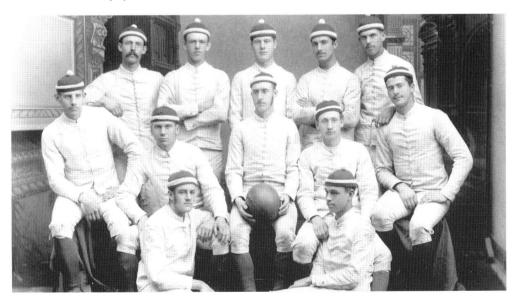

In 1880, the players were issued their first uniforms. The new threads consisted of a white canvas jacket with sleeves, white canvas pants, maroon stockings, and a maroon-and-white stocking cap. Since 1880, the student-athletes have worn the university colors of maroon and white. (Courtesy of Special Collections and University Archives, W. E. B. Du Bois Library.)

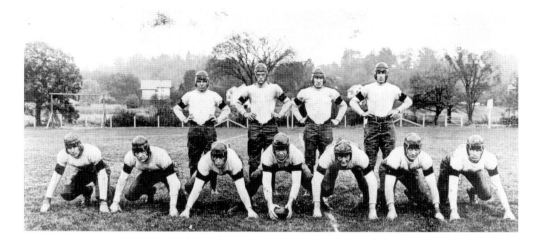

The 1921 football team struggled through a 3-4-1 season, which was highlighted by three shutouts: 13-0 over Connecticut, 35-0 over Worcester Polytech, and 14-0 over Tufts. From left to right, in formation, are (first row) Raymond Grayson, Robert Mohor, Ken Salmon, Stanley Freeman, Vernon Mudgett, captain George Cotton, and Wilbur Marshman; (second row) Richmond Sargent, Malcolm Tuney, John Lewandoski, and Herbert Collins. The team was coached by Harold "Kid" Gore '13. (Courtesy of Special Collections and University Archives, W. E. B. Du Bois Library.)

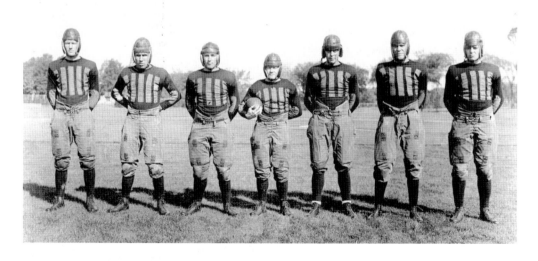

Before face masks and significant padding, the players also had to endure playing the game in leather helmets. Massachusetts Agricultural College fielded some very competitive teams in its history: the 1901 team went 9-1 and outscored its opponents 93-30. The team had three major victories: 17-0 over Holy Cross, 6-0 over Wesleyan, and an 11-0 victory over Boston College. In 1920, it went 5-2-1 and outscored its opponents 126-64. (Courtesy of Special Collections and University Archives, W. E. B. Du Bois Library.)

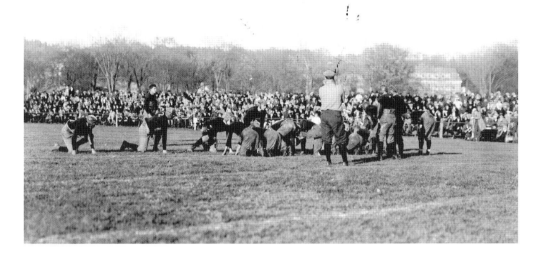

This is a photograph of the Amherst College-vs.-MAC Aggie football game held on October 21, 1922. MAC won 10-6. (Courtesy of Special Collections and University Archives, W. E. B. Du Bois Library.)

In 1920, Massachusetts Agricultural College lost one of its finest characters with the passing of Allan L. Pond of Holliston (August 28, 1896–February 26, 1920). Pond entered MAC with the class of 1919 and made a name for himself in athletics and campus politics. In his sophomore year, he made all three varsity teams in football, basketball, and baseball and was elected president of his class. He enlisted in the 14th Railway Engineers during the summer of 1917 and saw 16 months of active service in France, where he was gassed and contracted a severe case of rheumatism. He died in the winter of his senior year from complications from serving in World War I. (Courtesy of Special Collections and University Archives, W. E. B. Du Bois Library.)

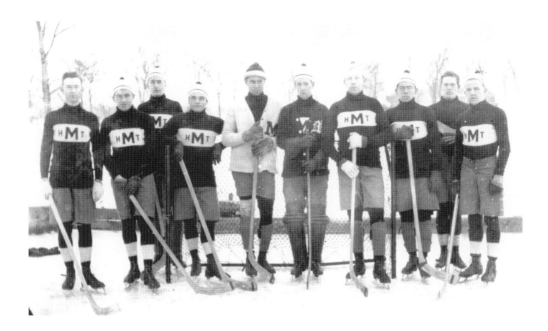

This picture shows the 1910–1911 men's ice hockey team standing on their home ice, the Campus Pond. The sticks were heavy, the stick blades were straight, and the skate blades were dull, but the MAC hockey team made its debut on the Campus Pond in 1909 with a 1-0 loss to Mass. Tech. (Courtesy of Special Collections and University Archives, W. E. B. Du Bois Library.)

The Campus Pond, home of the Aggies hockey team, was not an ideal place to play ice hockey. Many games were interrupted by inclement weather, and the conditions of the ice were less than desirable. The pond served as home ice through the 1938–1939 season.

Howard Reynolds Gordon '23 of Ipswich poses on the pond before a hockey game. Gordon was the coach of the 1923–1924 hockey team. His team beat Williams College 2-0 and Bates College 5-3. (Courtesy of Special Collections and University Archives, W. E. B. Du Bois Library.)

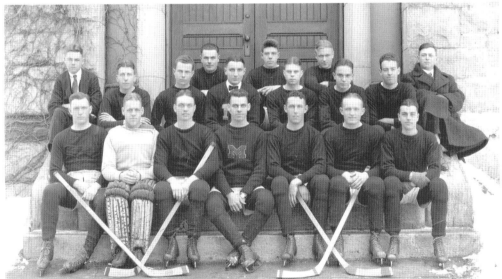

A long tradition of hockey players hailing from Arlington began in the early days of hockey at MAC. In this photograph, five of the players were from Arlington. From left to right are (first row, seated, starting third from the left) Elton Jessup Mansell '21, Justin Jeremiah McCarthy '21, Herbert Laurence Collins '22, John Joseph "Sharky" Lyons Jr. '22, and John Dow Snow '21. (Courtesy of Special Collections and University Archives, W. E. B. Du Bois Library.)

Justin Jeremiah McCarthy '21 was a gifted athlete at MAC. He attended Arlington High School, and while at MAC he was the shortstop for the varsity baseball team and the captain of the men's ice hockey team. In 1924, he won a silver medal in ice hockey at the Olympic Games in Paris, France.

John Joseph "Sharky" Lyons Jr. '22 played defense for the U.S. Olympic ice hockey team in 1924 with his teammate Justin J. McCarthy. Seven of the ten players on the 1924 U.S. Olympic hockey team were from the Commonwealth of Massachusetts. Two of them were from MAC.

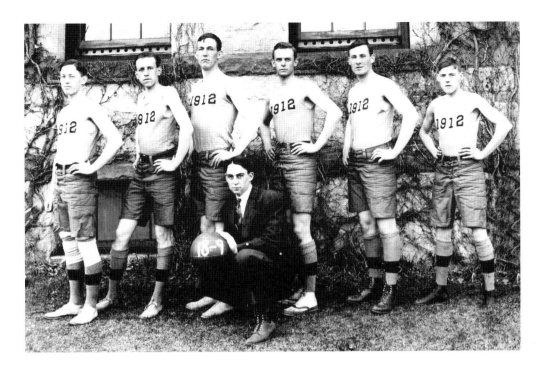

The freshman basketball team of 1912 had a respectable record of 18 wins and 9 losses vs. the other members of the class. Basketball at Massachusetts Agricultural College started in the 1899–1900 school year. The team used to play area YMCA and town teams. The college abandoned the game of basketball after the 1908–1909 season. It was not until the 1916–1917 season, under coach Harold "Kid" Gore '13 that basketball returned to campus to stay. (Courtesy of Special Collections and University Archives, W. E. B. Du Bois Library.)

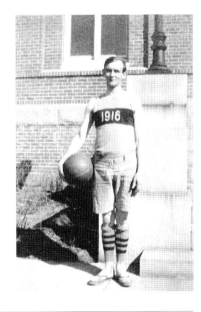

This player, in his 1916 shirt, is standing in full basketball uniform, including the patented tank top. Basketball was played in the Drill Hall before the construction of the Curry Starr Hicks Cage in 1931. (Courtesy of Special Collections and University Archives, W. E. B. Du Bois Library.)

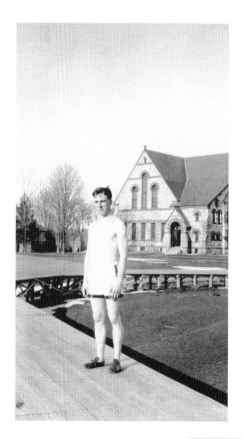

John Francis Dee '12, affectionately known as "Hinky," hailed from Worcester. In 1912, Dee held the Massachusetts Agricultural College record in the 880-yard run with a time of two minutes and nine seconds. It was a feat in itself to run such a competitive time on a raised wooden track, as seen in this photograph. (Courtesy of Special Collections and University Archives, W. E. B. Du Bois Library.)

David Story Caldwell '13 (second row, second from the left) of South Byfield held the MAC record in the mile run with a time of four minutes and 54 seconds. Caldwell qualified for the 1912 Olympic games with his running prowess. This photograph was taken at the Hartford, Connecticut, Armory Meet on February 21, 1911. (Courtesy of Special Collections and University Archives, W. E. B. Du Bois Library.)

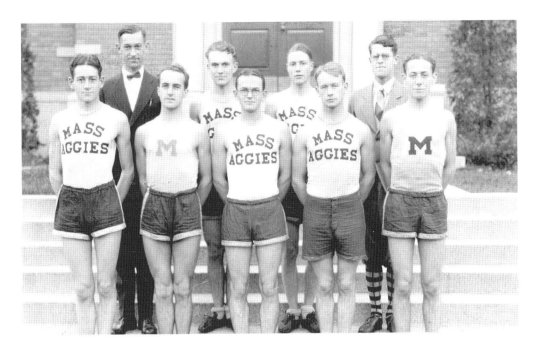

The 1926 cross-country team compiled a league meet record of 5-0. The team beat Tufts, Williams, Wesleyan, Amherst, and Boston University. From left to right are (first row) Harry "Red" Nottebaert '27 of Lexington, Thomas Henneberry '27 of Manchester, captain Clarence Crooks '27 of North Brookfield, Rapheal Biron '27 of Amesbury, and Frederick Swan '27 of Milton; (second row) coach Llewellyn Derby; Robert Snell '29 of Southbridge, Charles Preston '28 of Hawthorne, and manager Frank Stratton '28 of Lawrence. (Courtesy of Media Relations.)

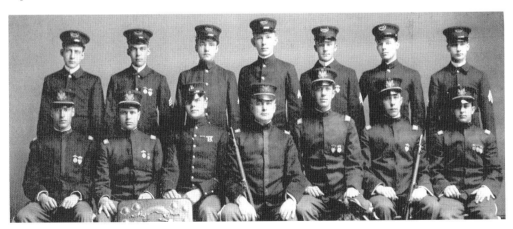

The Massachusetts Agricultural College rifle team of 1911 is shown here. The rifle team is one of the first teams that competed on an intercollegiate level at MAC. This team won both the indoor and outdoor intercollegiate championships in 1911. (Courtesy of Special Collections and University Archives, W. E. B. Du Bois Library.)

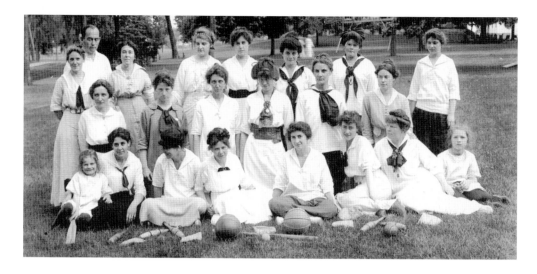

This photograph depicts a group of female students posing with various sporting equipment in recreation class. Women's intercollegiate sports programs were not organized until the 1970s. Women's sports became more formal with the creation of the Women's Athletic Association in 1925. Women were able to compete against one another in swimming, archery, field hockey, softball, volleyball, fencing, skiing, and bowling. (Courtesy of Special Collections and University Archives, W. E. B. Du Bois Library.)

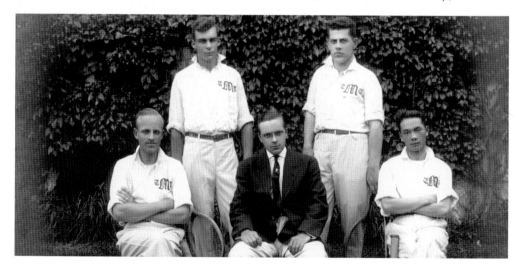

The 1911 men's tennis team posted six wins and three losses. The wins included victories over Springfield College (two), Connecticut Aggie, Holy Cross, University of Vermont, and Holyoke Canoe Club. The team lost to Union, Rensselaer, and Trinity. From left to right are (first row) Herman T. Roehers '14 of New York City, manager Jay Heald '12 of Watertown, and Dau Yang Lin '12 of Shanghai, China; (second row) Alden Brett '12 of North Abington, and Lawrence Johnson '13 of Easthampton. (Courtesy of Special Collections and University Archives, W. E. B. Du Bois Library.)

Massachusetts State College Statesmen

1931–1947

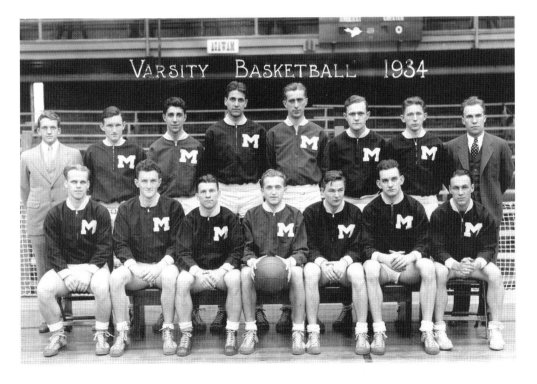

Teamwork was the word for the 1934 Massachusetts State College basketball team. The team went 12-0 vs. its opponents. From left to right are (first row) Wilho Frigard '34, John Stewart '36, Lou Bush '34, Joe Lojko '34, Ernest Jaworski '35, William Davis '35, and John Consolotti '35; (second row) manager Arthur Merrill '34, Malcolm Stewart '34, Edward Nassif '35, Robert Allen '35, John McConchie '36, William Muller '35, Carrol Thayer '35, and coach Melvin Taube. This team yielded three future UMass athletic Hall of Famers: John Stewart, Lou Bush, and Joe Lojko. (Courtesy of Media Relations.)

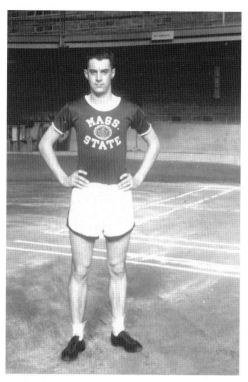

George Brown Caldwell '44 of Littleton lettered in three sports: cross-country, winter track, and spring track. The varsity teams were watered down during the war years between 1941 and 1945. Many sports were not played, and others had partial rosters. (Courtesy of Special Collections and University Archives, W. E. B. Du Bois Library.)

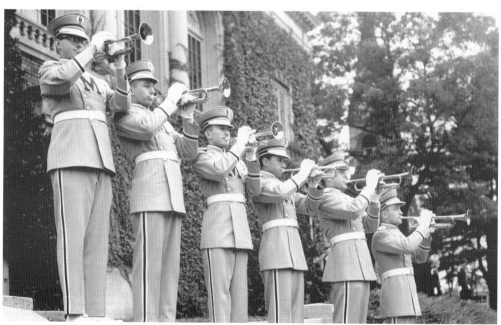

Members of the Massachusetts State College Band play on the steps of Memorial Hall in this c. 1945 photograph. (Courtesy of Special Collections and University Archives, W. E. B. Du Bois Library.)

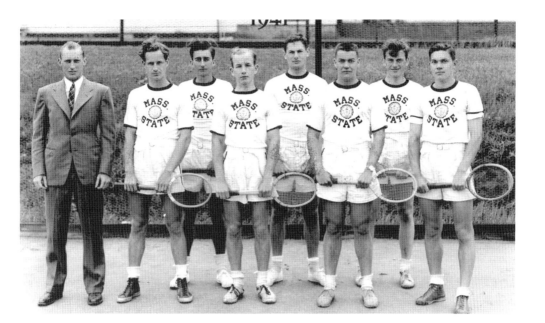

The 1941 tennis team is shown in this photograph. From left to right are manager John Shepardson '42 of Athol, Edward Nebesky '43 of Amesbury, Lucien Scmyd '42 of Holyoke, Edward Anderson '45 of Scituate, Howard Kirshen '42 of Mattapan, Howie Lacey '42 of Fitchburg, Howard Shaw '42 of Canton, and James Graham '42 of Middleboro. (Courtesy of Special Collections and University Archives, W. E. B. Du Bois Library.)

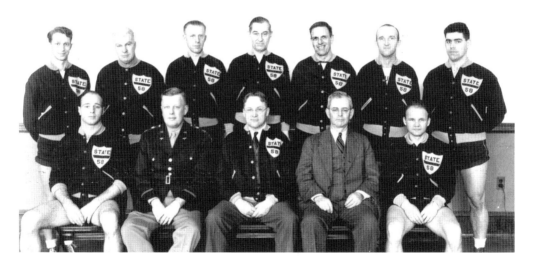

These coaches pose with their lettermen's jackets on around 1948. From left to right are (first row) Thomas Eck, coach Congleton, Harold "Kid" Gore '13, Curry Starr Hicks, and Fred "Fritz" Ellert '30; (second row) Henry Thornton, Lorin Ball '21, Donald Ross, Llewellyn Derby, Lawrence Briggs, Joe Rogers, and George Pushee. (Courtesy of Special Collections and University Archives, W. E. B. Du Bois Library.)

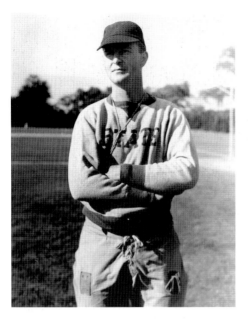

Massachusetts State College (MSC) football coach Walter Hargsheimer stands on the practice field with his arms crossed. Hargsheimer coached the MSC football team in the 1941, 1942, and 1946 seasons. (Courtesy of Special Collections and University Archives, W. E. B. Du Bois Library.)

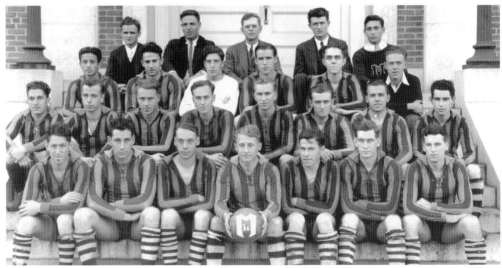

The second year that soccer was an intercollegiate sport, the 1931 men's team went 6-0, defeating all opponents. From left to right are (first row) Harold Shuman '33, Phil Connell '32, John Hitchcock '32, captain Edward Waskiewicz '32, Joseph Jorczak '32, Herbert Forest '32, and future UMass Hall of Famer Granville Pruyne '33; (second row) John Astore '32, Philip Warren '32, George Hodson '33, Russell Taft '34, Roy Cowing '34, Robert Jackson '34, William Kozlowski '34, and James Machimmie '34; (third row) Harry Bernstein '34, Eliot Landsman '35, Descom Hoagland '34, Edward Talbot '34, Nathaniel Hill '34, and unidentified; (fourth row) assistant coach Fritz Ellert '30, coach Larry Briggs, Curry Starr Hicks, Peter Stanislewski, and manager Eugene Guarlnick '33. (Courtesy of Special Collections and University Archives, W. E. B. Du Bois Library.)

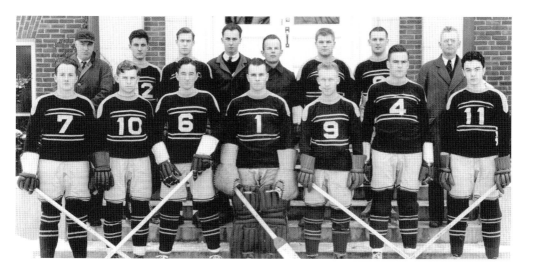

The 1939 varsity hockey team stands in front of the Curry Hicks Cage. The end of the season marked the end of hockey as a varsity sport until 1950. From left to right are (first row) James Buckley '40, Edward Stoddard '39, William Fitzpatrick '39, UMass Hall of Famer captain Clifton Morey '39, Thomas Lyman '39, Chester Conant '39, and Edward LaFreniere '41; (second row) coach Lorin "Red" Ball '21, Richard Knight '41, Chester Gove '39, manager Edward Willard, Albert Ackroyd '41, Malcolm Harding Jr. '40, Harvey Barke '39, and director of athletics Curry Starr Hicks. (Courtesy of Special Collections and University Archives, W. E. B. Du Bois Library.)

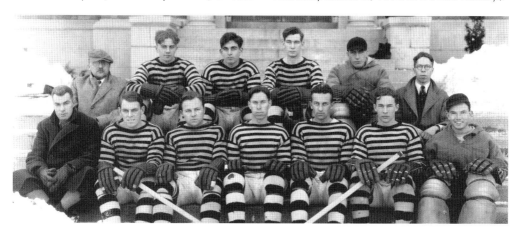

The 1931 MSC varsity hockey team had a successful winter of 1931 with a 9-3 record. Notable wins were 5-1 over Army, 3-0 over Northeastern, and 3-2 over New Hampshire. From left to right are (first row) coach Lorin "Red" Ball '21, Richard Hammond '33, Charles Manty '31, captain Edmund Frost '31, Richard Davis '31, Arthur Brown '32, and Norman Myrick '31; (second row) assistant coach Harold "Kid" Gore '13, John Tikofski '32, UMass Hall of Famer George "Sugar" Cain '33, Herbert Forest '32, Ernest Mitchell Jr. '32, and manager F. Kinsley Whittum '31. (Courtesy of Special Collections and University Archives, W. E. B. Du Bois Library.)

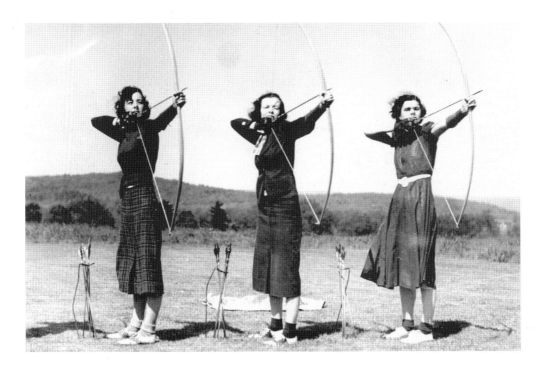

Three women are shown here in archery class in 1946. The Women's Athletic Association promoted sports activity for women. Archery was one of the activities women had the option to compete in before intercollegiate competition. (Courtesy of Special Collections and University Archives, W. E. B. Du Bois Library.)

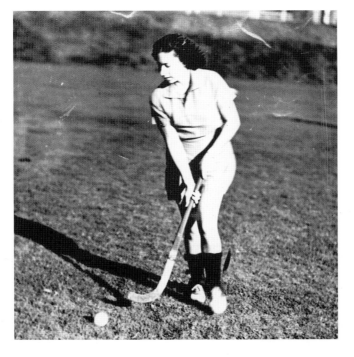

A woman in gym class is shown moving the ball toward the goal in 1944. While many of the men's sports were on hold during World War II, women were able to spend more time on the athletic fields. (Courtesy of Special Collections and University Archives, W. E. B. Du Bois Library.)

These members of the 1933 Massachusetts State College freshman cross-country team seem happy after a hard day on the roads.

(Courtesy of Special Collections and University Archives, W. E. B. Du Bois Library.)

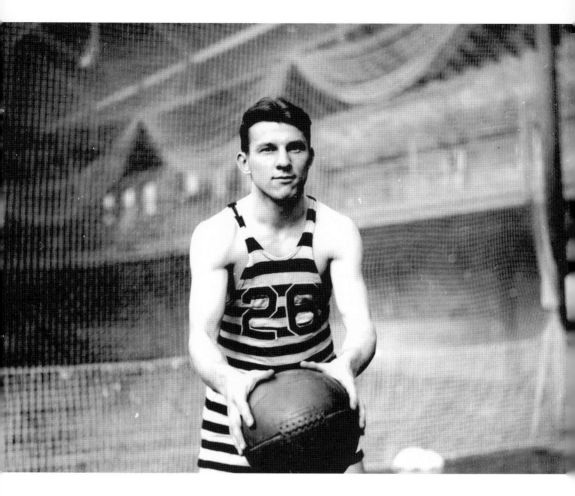

This is Lou Bush, one of the most versatile athletes ever to attend UMass. He received varsity letters in football, basketball, and baseball from 1931 to 1934. Bush was elected in the charter class of the UMass Hall of Fame in 1969. (Courtesy of Special Collections and University Archives, W. E. B. Du Bois Library.)

University of Massachusetts Redmen

1947–1976

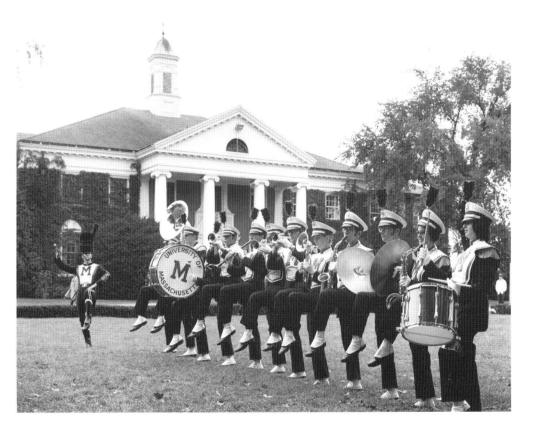

The 1950 University of Massachusetts Redmen Marching Band is seen here practicing in front of Goodell Library. The marching band has been a mainstay on campus since 1885. The Minuteman Band of today was officially organized in 1935 under the direction of Charles Farnum. The band has evolved into a nationally recognized organization with 300 members. (Courtesy of Media Relations.)

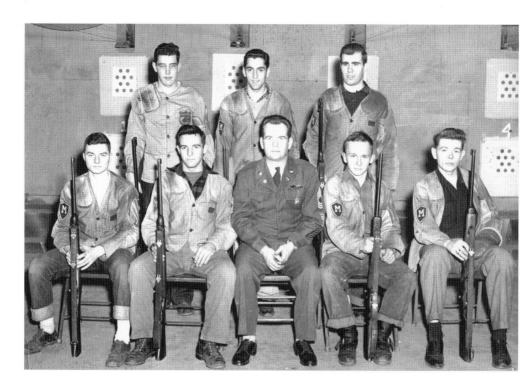

The 1951 men's rifle team beat Worcester Polytechnic, University of New Hampshire, and Bowdoin. The team lost to Norwich University, University of Maine, Massachusetts Institute of Technology, and Dartmouth. From left to right are (first row) Roger Bartels, Kenneth Alves, Sgt. Harry H. Platt, Warren Wilson, and Roger Kelley; (second row) Paul Durkee, Bernard Zulalian, and Huntington Williams. (Courtesy of Media Relations.)

Members of the 1957 men's varsity track team joke with coach Llewellyn Derby. Track and field is one of the oldest sports on campus, dating back to 1897. (Courtesy of Media Relations.)

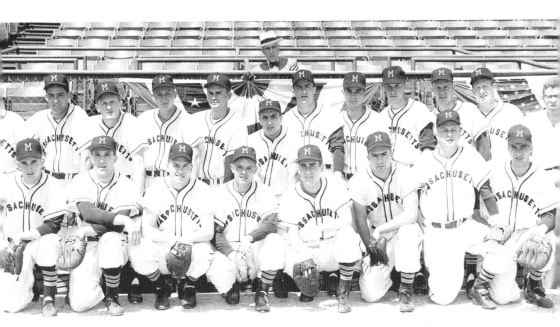

Far surpassing all preseason predictions, the 1954 varsity baseball team posted a 15-7 record (4-2 in the Yankee Conference) and traveled to Omaha, Nebraska, to play in the College World Series. The team witnessed brilliant pitching by Don Swanson and UMass Hall of Famer Phil Tarpey. At the World Series, the Redman nine lost their first game to Michigan State 16-5, won their second game against Oregon 5-3, and lost their third game to Missouri 8-1. This photograph was taken on June 10, 1954.

From left to right are (first row) John Winters, Raymond Rhodes, James Eagan, Bryan Wilcox, John Pasteris, Victor Bissonette, James Rivers, and Lynwood Sutcliff; (second row) coach Earl Lorden, captain Robert Pedigree, John Skypeck, Richard Norman, Joseph Faucette, Paul DiVincenzo, Louis Gobeille, Felix Wisniewski, Allen Anderson, Don Swanson, Phil Tarpey, and manager Lawrence Hoff. (Courtesy of Media Relations.)

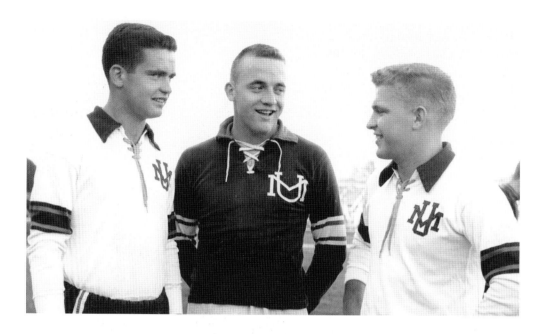

From left to right, Bernard Goclowski '59, Richard Williams '61, and George Lust '60 conference during a varsity soccer practice in 1958. (Courtesy of Special Collections and University Archives, W. E. B. Du Bois Library.)

Judy Lawson '61 of Taunton (center) was crowned homecoming queen on October 8, 1960. She is surrounded by members of her court (clockwise from lower left) Rosalynn Zacher '62 of Boston, Bette Broberg '63 of Worcester, Deborah Read '62 of Walpole, and Carol Madison '63 of Pittsfield. (Courtesy of Media Relations.)

Arlington native Jim Ellingwood (1959–1962) is all business in this 1962 photograph. Ellingwood ranked 16th in all-time scoring in 2005, with 32 goals and 38 assists for a total of 70 points. Ellingwood was the captain of the 1961–1962 men's hockey team. (Courtesy of Media Relations.)

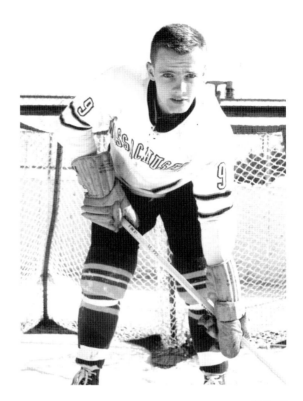

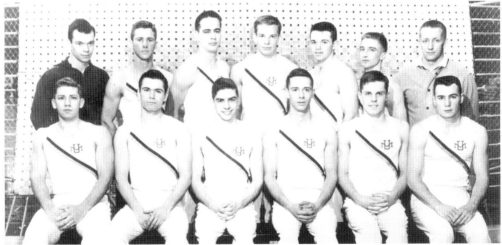

The 1961 men's varsity gymnastics team is shown here. The team ended the season with a 3-2 record, defeating Cortland State twice and Southern Connecticut for the third victory. From left to right are (first row) Lee Munson, Donald Cleary, Ralph Nichols, captain James Bitwood, Bruce McCracken, and James Adam; (second row) unidentified, M. Steeves, Charles Paydos, Richard Peloquin, Robert Sloan, David Yates, and coach Robert James. Men's gymnastics was discontinued as a varsity sport at the end of the 2002–2003 season. (Courtesy of Special Collections and University Archives, W. E. B. Du Bois Library.)

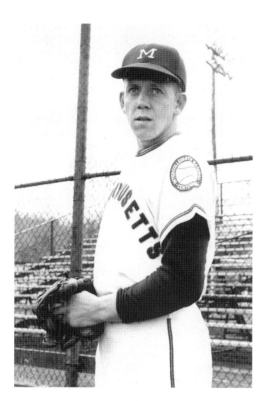

Paul Wennick '61 was elected to the All-Yankee Conference team, posted a 1.24 earned-run average, and a 5-1 record in 1961. Later that year, the Washington Senators drafted him in the major-league baseball draft. Wennick is currently very active in many fund-raising activities for the baseball and football teams. (Courtesy of Media Relations.)

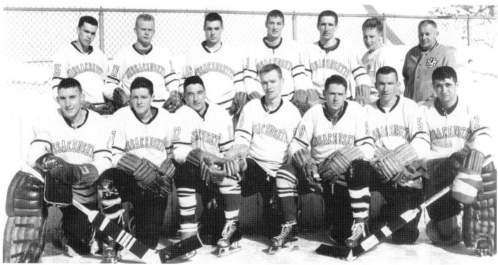

The 1960–1961 men's ice hockey team (7-6-1) is shown here outside the Walter S. Orr Rink at Amherst College. The hockey team played at Orr Rink from 1954 to 1979. From left to right are (first row) captain Bob Roland, Jerry Clinton, Art Stevens, Jim Ellingwood, Tom Taylor, Charles Donovan, and Frank Cesario; (second row) Frank Gilliatt, Dave Kennedy, Pete Bracci, Al Chertien, Robert Glew, William Ryan, and coach Steve Kosokowski. (Courtesy of Special Collections and University Archives, W. E. B. Du Bois Library.)

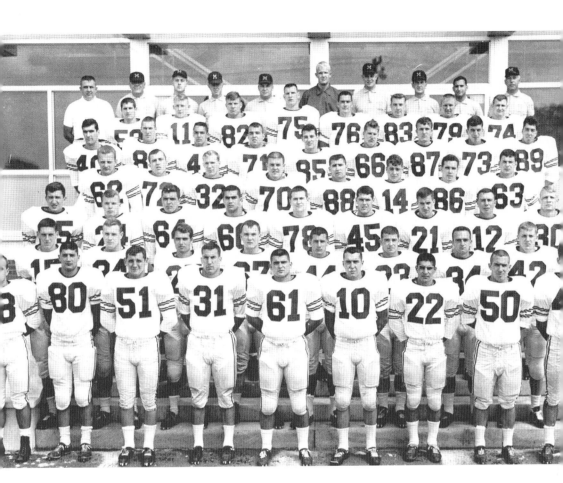

The 1964 football team finished the season with an 8-2 record (5-0 in the Yankee Conference) by outscoring its opponents 222-76. The team advanced to the Tangerine Bowl on December 12, 1964, and lost to the East Carolina Pirates 14-13. The 1964 team produced five future UMass Hall of Famers: Bernie Dallas (No. 51), Jerry Whelchel (No. 10), Milt Morin (No. 82), Bob Meers (No. 83), and head coach Vic Fusia (top right). (Courtesy of Media Relations.)

These fans are enjoying a football game at the new McGuirk Alumni Stadium in 1965. (Courtesy of Special Collections and University Archives, W. E. B. Du Bois Library.)

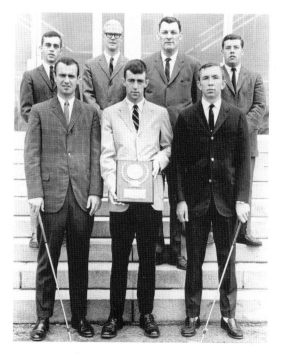

Shown here is the 1966 varsity golf team, which won the Yankee Conference championship. From left to right are (first row) Vin Puglia, Robert McNeil, and Ed Polchlopek; (second row) John Pollack, David MacIver, coach Chet Gladchuk, and Joe DiDonato. (Courtesy of Special Collections and University Archives, W. E. B. Du Bois Library.)

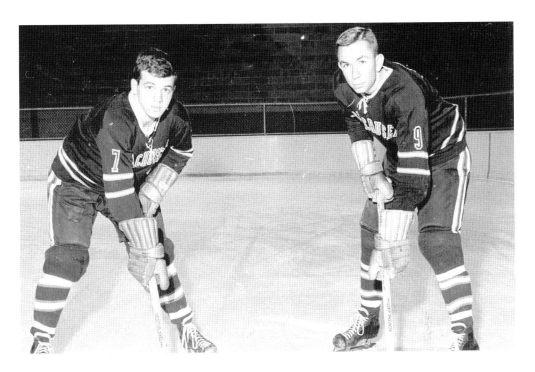

Bill Skowyra (left) and Ed Polchlopek pose in uniform before the 1967 season. Skowyra finished his career with 23 goals and 39 assists, for a total of 62 points. Polchlopek finished his career with 42 goals and 24 assists, for a total of 66 points. The team went 8-11-1 in the 1966–1967 season. (Courtesy of Media Relations.)

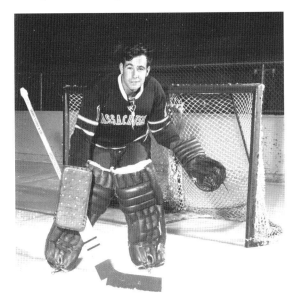

Ed Sanborn of Gloucester played goalie for the UMass Redmen ice hockey team in the 1965, 1966, and 1967 seasons. Sanborn once stopped 79 pucks in an 8-0 loss to the University of New Hampshire in 1967. (Courtesy of Media Relations.)

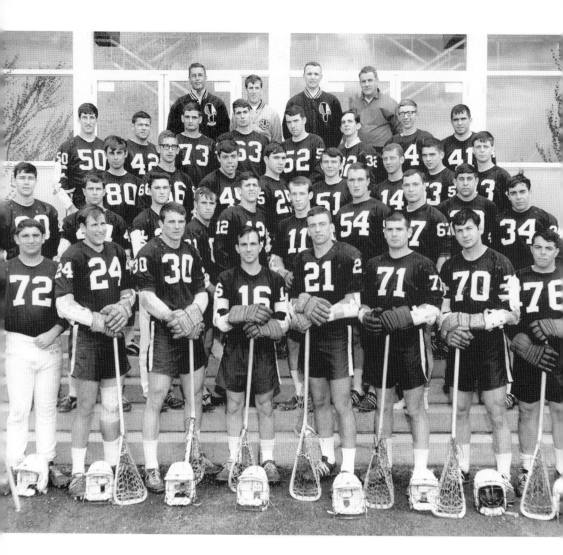

The University of Massachusetts men's varsity lacrosse team is shown here in the 1967 annual team photograph. The team posted an 8-4 record. The season was highlighted by a 35-point performance by Kevin O'Connor, with 25 goals and 10 assists. O'Connor finished his career with 92 goals and 71 assists, for 163 points. He was the school's all-time leading scorer until the 1977 season. From left to right are (first row) Ira Yavner, Fred Molander, tri-captain Bob Murphy, tri-captain Howie Goffman, tri-captain Kevin O'Brien, Fred Foley, Don Rana, and Bob Astorino; (second row) Gary Vassar, Steve Connolly, Steve Anderson, Dick Mahoney, Marty Kalikow, Kevin O'Connor, Walt Alessi, Paul Muchovic, Mark Schlossberg, and Bill Sinclair; (third row) Gerry Brown, Mike Brown, Tom Voisin, Don Agnoli, Dan Murley, Jeff Gull, Steve Chambers, and Don Legg; (fourth row) Greg Norton, Bill DeRosa, Tom Tufts, Gerry Forgit, Sean Walker, Brad Herling, George Zebrowski, and Kevin Collins; (fifth row) coach Dick Garber, Glen Thiel, Jim Laughane, and Gordon Neylon. (Courtesy of Media Relations.)

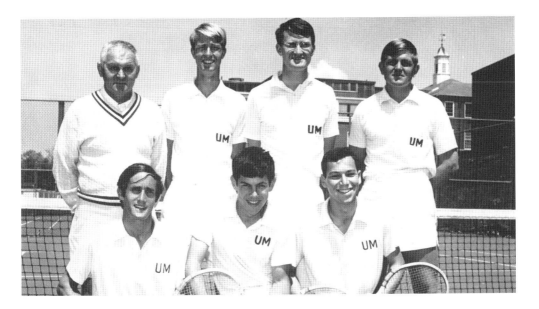

Shown here is the Yankee Conference Champions men's varsity tennis team of 1968. Tennis is one of the oldest varsity sports played on campus, dating back to 1891. From left to right are (first row) Al Davis, Steve Cohen, and Mile Katz; (second row) coach Steve Kosakowski, Scott Sheppard, Carl Clem, and Tom Johnson. Men's tennis was dropped in 2003, after 110 years of competition. (Courtesy of Special Collections and University Archives, W. E. B. Du Bois Library.)

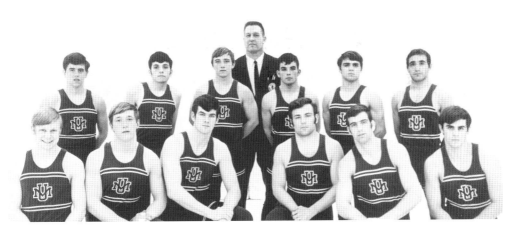

The 1969–1970 wrestlers, led by coach Homer Barr (back row, center) completed the most successful season in UMass wrestling history, going 16-4. From left to right, members of the wrestling team are (first row) Steve Jones, Bruce Buckbee, Chris Hodson, captain George Zguris, Mike Brauner, and Tom Young; (second row) Barry Godowsky, Sheldon Goldberg, Clay Jester, Phil Davis, Dave Reynolds, and Nick Domenico. Wrestling was dropped as a varsity sport in 1985. (Courtesy of Special Collections and University Archives, W. E. B. Du Bois Library.)

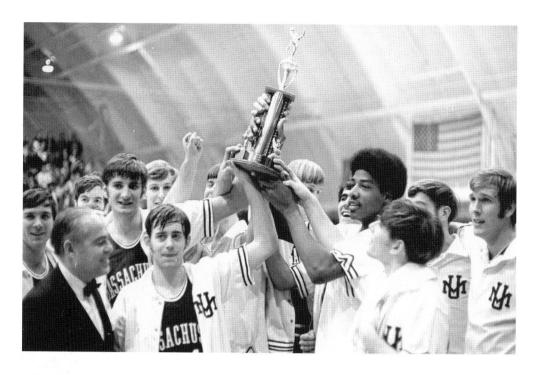

The 1970–1971 UMass Redmen basketball team posted an outstanding 23-4 record. The team had a perfect 10-0 record in the Yankee Conference. In this photograph, the team celebrates the Yankee Conference championship. UMass Hall of Famer Julius Erving (second from the right) has both hands on the trophy. (Courtesy of Dr. James Ralph.)

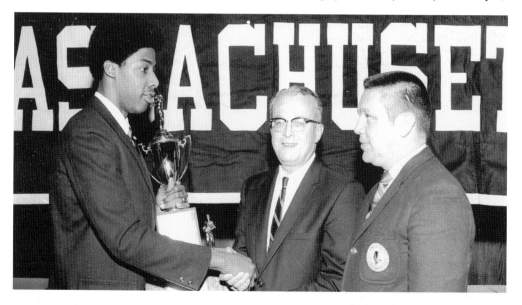

Julius Erving (left) receives the Most Valuable Player (MVP) Trophy in 1971 from UMass president John Lederle. Looking on is coach Jack Leaman. (Courtesy of Media Relations.)

Dennis Keating of Arlington was the co-captain of the Yankee Conference championship team of 1971. Keating, a corner back, was selected as a first-team All Conference player in 1970. He is currently the vice president of membership for the UMass Friends of Football booster club. (Courtesy of Media Relations.)

UMass Redman goalie Pat Flaherty of South Boston looks like NHL great Ken Dryden. Flaherty holds the UMass hockey record, with 38 career wins. He currently ranks fifth in saves, with 1,306, and fourth in minutes played, with 3,482. He was named an All-American after the 1971–1972 season. (Courtesy of Media Relations.)

Bill DeFlavio '72 was a punishing defensive tackle for coaches Vic Fusia and Dick MacPherson in the 1969, 1970, and 1971 seasons. DeFlavio stood five feet, eight inches tall, and weighed 230 pounds. He was fearless on the football gridiron. He was a first-team All-American in 1971, as well as a member of the All-Yankee Conference team in 1971. He currently serves as the president of the Friends of UMass Football. (Courtesy of Media Relations.)

The University of Massachusetts ski team has become one of the most consistent and winningest teams on the UMass Amherst campus. Bill MacConnell (fifth from the left) coached the men's ski team from 1961 to 2001. The 1972 team won the New England Osborne Division championship. Members of the ski team are, from left to right, Dick McWade, David Rutter, Tuck Woodruff, Jerry Curran, Bill MacConnell, Kurt Syer, Larry Peck, and Phil McKeague. Dave Ferris and Jim Ahearn are missing from the photograph. (Courtesy of Special Collections and University Archives, W. E. B. Du Bois Library.)

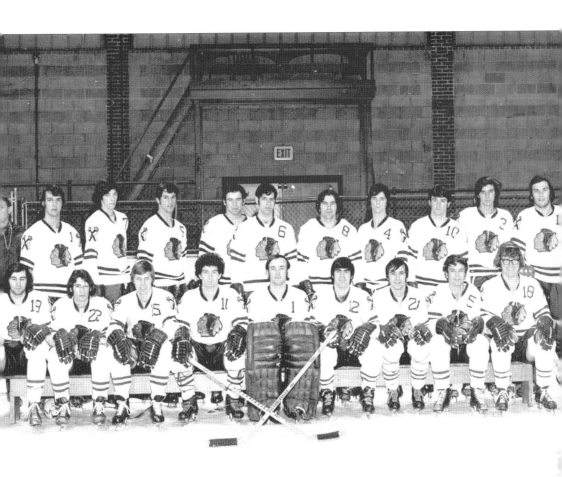

The 1971–1972 University of Massachusetts Redmen hockey team posted a 19-7 overall record and an 18-3 Division II record. On March 11, 1972, the Redmen beat the University of Buffalo 8-1 in front of a hometown crowd at Orr Rink to clinch the ECAC Hockey Division II national championship. From left to right are (first row) Jack Edwards, Charlie Donovan, Eric Scrafield, Bob Bartholomew, Pat Flaherty, Al Nickerson, Dennis Grabowski, Mike Waldron, and Dan Reidy; (second row) coach Jack Canniff, John Kiah, Jim Coleman, Don Riley, Don Lowe, Bob Shilalie, Bob Shea, future Hall of Famer Pat Keenan, Jim Lynch, Lonnie Avery, and Charlie Rheault. Captain Brian Sullivan is missing from the photograph. (Courtesy of Media Relations.)

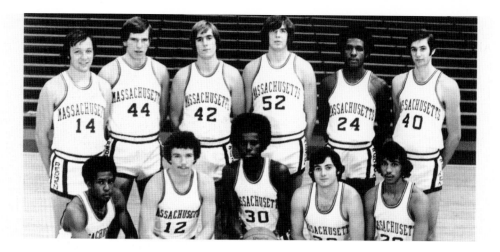

The 1973–1974 University of Massachusetts men's varsity basketball team had a successful season, ending with a 21-5 overall record and an 11-1 record in the Yankee Conference. From left to right are (first row) Mike Stokes, Bill Endicott, captain Al Skinner, Rick Pitino, and Bill Santos; (second row) Jim Burke, John Olson, Steve Mayfield, John Murphy, Greg Duarte, and Joe Semder. This team produced two nationally known head basketball coaches: Skinner, currently coaching at Boston College, and Pitino, currently coaching at Louisville. (Courtesy of Special Collections and University Archives, W. E. B. Du Bois Library.)

On April 21, 1973, in Des Moines, Iowa, the UMass women's gymnastics team captured its first ever AIAW intercollegiate gymnastics national championship title under the direction of head coach Virginia Evans. From left to right are (first row) Jeannine Burger, Betsy East, Marjie Combs, and Marian Kulick; (second row) coach Mike Kasavanasst, Heidi Armstrong, Alicia Goode, Anne Vexler, and head coach Virginia Evans.. Combs was the highest individual event finisher for the Minutewomen, claiming second place on the uneven bars. In all-around competition, Vexler placed fourth, Burger sixth, and Combs 10th. Both Burger and Vexler became members of the UMass Hall of Fame. (Courtesy of Media Relations.)

Thomas Coburn was named an All-American forward in 1974 after leading UMass men's soccer to an 8-3-1 record. He scored 25 points in 1974, and ranks fifth on the school's all-time scoring list. (Courtesy of Media Relations.)

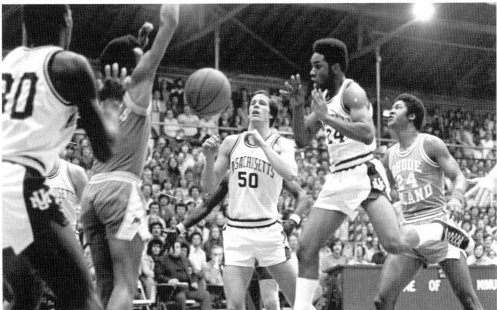

Alex Eldridge (No. 24), seen here passing the ball, was a terrific basketball player for coach Jack Leaman from 1975 to 1978. The six-foot-two-inch, 188-pound guard from Taft High School in New York City finished his UMass career with 1,053 points and 270 rebounds. He had a career game high of 25 points against Duquesne on January 11, 1975. (Courtesy of Dr. James Ralph.)

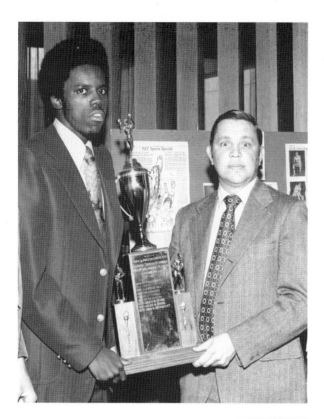

Al Skinner '74 (left) and coach Jack Leaman hold Skinner's 1973 MVP Trophy. The trophy is named the George "Trigger" Burke Most Valuable Player Award. (Courtesy of Media Relations.)

Rick Pitino earned his degree in 1974 at UMass, where he was a versatile guard for the Minutemen's basketball team. His 329 career assists rank eighth all-time at UMass. His 168 assists as a senior are the sixth-best single season total ever at UMass. Pitino won the 1996 NCAA title in his seventh year at Kentucky. In 1997, he became coach and president of the Boston Celtics. He resigned from the Celtics in 2001 and returned to college coaching in Louisville. (Courtesy of Media Relations.)

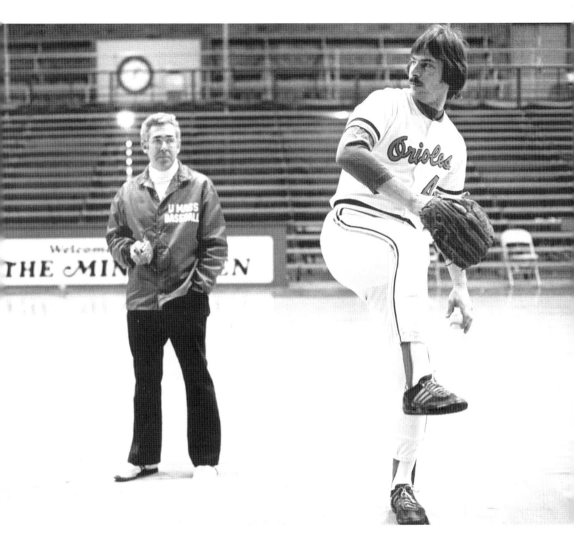

Coach Dick Bergquist displays a little clout in 1976 by bringing in Mike Flanagan '75 to his summer baseball camp. Flanagan arrived in his major-league Baltimore Orioles uniform to give the kids some pointers. Three years later, Flanagan won the American League Cy Young Award.

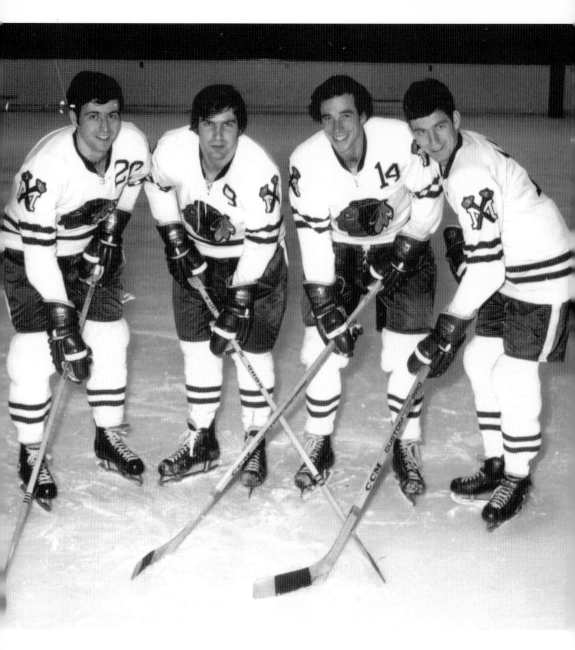

Shown here are members of the 1970–1971 University of Massachusetts Redmen varsity hockey team. All of these men, continuing the long-standing hockey tradition, are from Arlington. From left to right are Tom Peters, Bob Shea, Fran Mulcahy, and Bob Bartholomew. The 1970–1971 team went 14-6-1 and lost to the University of Vermont in the ECAC Division II playoffs. (Courtesy of Media Relations.)

UNIVERSITY OF MASSACHUSETTS MINUTEMEN

1976–2005

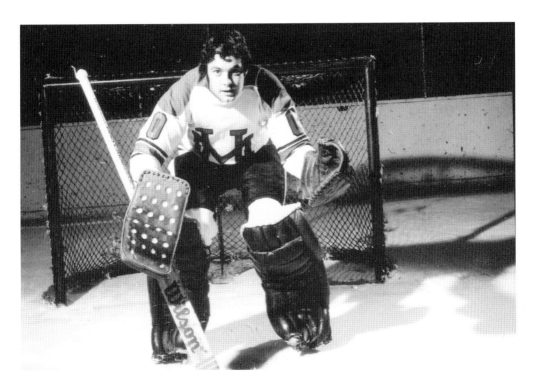

John Riley '78 played goalie for the Minuteman hockey team from 1974 to 1978. He stopped a total of 700 pucks and finished his career with a respectable 25.9 per game save percentage. Riley and other hockey alumni were instrumental in securing the funding for the state-of-the-art $52 million Mullins Center. Riley currently serves on the executive committee of the UMass Hockey Pond Club, the fund-raising and marketing arm of the UMass men's ice hockey program. (Courtesy of Media Relations.)

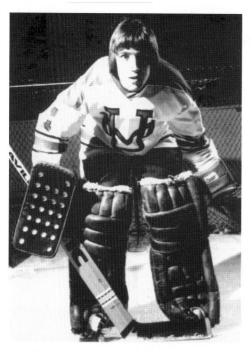

The other half of the tandem of Redmond and Riley, Dana Redmond played between the pipes from 1974 to 1977. Redmond stopped 1,545 career pucks in 62 games of competition. He posted a 24.9 career save percentage. (Courtesy of Media Relations.)

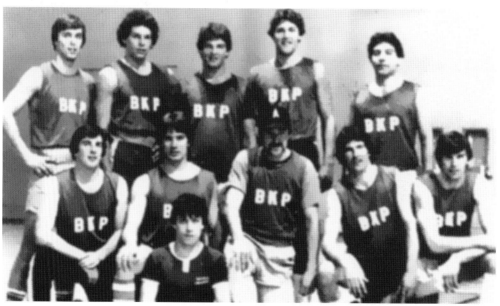

After winning the UMass Intramural championship, the 1978–1979 Beta Kappa Phi intramural basketball team made it all the way to Miami to play in the Schlitz Intramural Olympics. The team came in seventh out of 12 teams. From left to right are (first row) Michael Ognibene; (second row) Gary Bolduc, Steve Sweeny, Steve Flanders, Bruce Leaver, and Tim Hislop; (third row) Peter Barrar, Steve Myers, Gary Bernson, Dan Smith, and Jim Pallotta. (Courtesy of Zulma Garcia.)

Bobby Orr look-alike Mike Merchant played hockey at UMass from 1973 to 1977. Merchant finished his career with 99 points (38 goals and 61 assists) and served as the captain of the 1977 team. He currently serves as the president of the UMass Hockey Pond Club, the nonprofit fund-raising and marketing arm of the program. (Courtesy of Media Relations.)

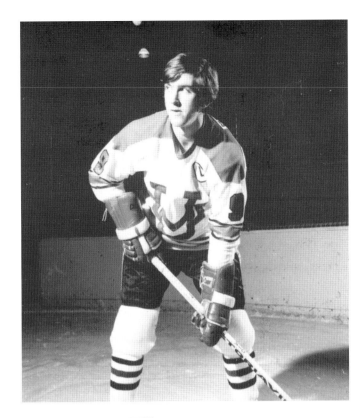

Billy Bayno was once recognized as one of the nation's premier assistant coaches. He served seven years as the associate coach at UMass (1988–1995) under then head coach John Calipari. Bayno played a major role in UMass's rise to national prominence, as the Minutemen made five consecutive trips to the NCAA tournament, advancing to the 1995 regional finals, and appearing in the 1996 NCAA Final Four. Bayno attended UMass from 1980 to 1982 and played guard under both Ray Wilson and Tom McLaughlin. (Courtesy of Media Relations.)

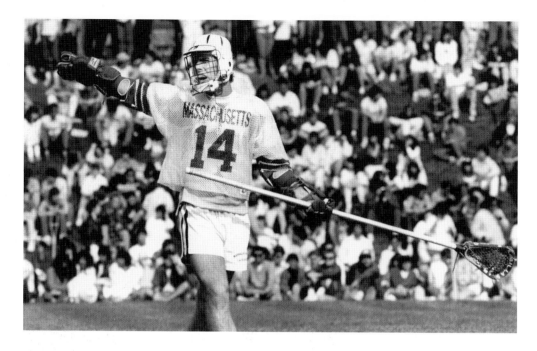

Tom Aldrich '86 is seen here directing his teammates. He was a defenseman for coach Dick Garber's lacrosse team from 1983 to 1986. Aldrich was elected to the All New England team in both 1985 and 1986. (Courtesy of Media Relations.)

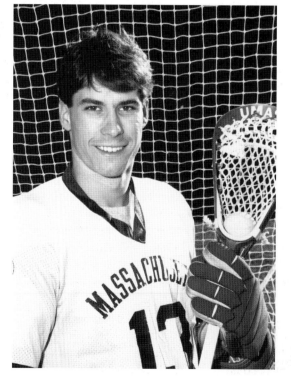

Steve Moreland served as co-captain of the 1986 men's lacrosse team with Tom Aldrich. The 1986 team went 10-5 and was ranked eighth in the country for most of the season. The team entered the NCAA tournament for the first time and beat the University of New Hampshire 16-6 and then lost to Johns Hopkins 13-6. (Courtesy of Media Relations.)

Greg Cannella '88 became head coach of the men's lacrosse team in 1994. He finished his UMass playing career with 33 goals and 31 assists. His 2005 team advanced to the Final Four by beating nine-time and defending national champions Syracuse 16-15 in the first round. The team lost to Johns Hopkins in the NCAA quarterfinals 19-9. (Courtesy of Media Relations.)

Thorr Bjorn earned three varsity letters in football from UMass between 1997 and 1999. He is currently the senior associate athletic director of UMass athletics. He is responsible for all marketing and corporate sales activities, including the UMass radio network, coach's shows, and signage. (Courtesy of Media Relations.)

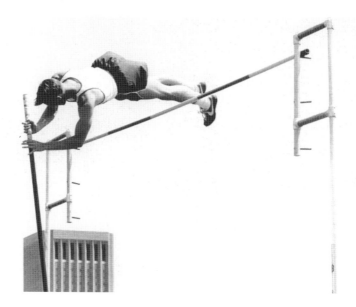

A pole-vaulter appears to be rising over the 26-story W. E. B. Du Bois Library at a track meet on the UMass campus. (Courtesy of Special Collections and University Archives, W. E. B. Du Bois Library.)

Brian "Corkie" Corcoran (six feet two inches tall, and 247 pounds) was a two-sport varsity athlete at UMass. He was named the Yankee Conference Defensive Player of the Year and earned second-team All-America honors in 1994. He finished his career ranked third on the school's all-time career sack list, with 30. When UMass hockey returned to campus in 1993–1994, Corcoran made the team as a walk-on defenseman. He was one of the six Minutemen named to the Yankee Conference 50th anniversary football team in 1996. (Courtesy of Media Relations.)

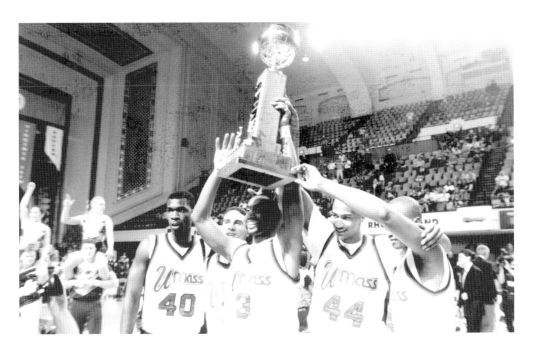

A group of players from the 1995–1996 season celebrate after winning UMass's fifth consecutive championship in the Atlantic 10 Tournament. From left to right are Inus Norville, Edgar Padilla, Dana Dingle (with trophy), Rigoberto Nunez, and Dante Bright. The 1995–1996 team advanced further than any other UMass team to the Final Four and lost to Rick Pitino's Kentucky Wildcats 81-74. (Courtesy of Media Relations.)

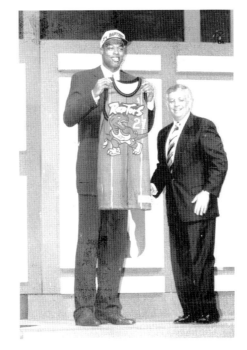

UMass basketball standout Marcus Camby is shown here with NBA Commissioner Dave Stern after being drafted by the Toronto Raptors in 1996. (Courtesy of J. Anthony Roberts, Advance Photography.)

Jason Germain '95 was a fan favorite off the bench for coach John Calipari in the 1994 and 1995 seasons. Germain currently serves as the assistant director of athletic development at UMass. (Courtesy of Media Relations.)

Greg Menton, the first full-scholarship athlete in the history of the UMass aquatics program, was a three-year member of the Minuteman swimming and water polo teams. On January 10, 1996, Menton collapsed during a dual meet at Dartmouth College and passed away. His No. 6 was retired on April 13, 1996. Menton received a posthumous bachelor's degree in sport management from UMass Chancellor David Scott. (Courtesy of Media Relations.)

In 1997, Doug Clark scored 51 runs, hit 11 home runs, posted 60 RBIs, ran 123 total bases, and posted a .415 season average, and he was named first-team A-10 to the All New England team and to the All Northeast team. Clark played eight games for the San Francisco Giants in the 2005 season. (Courtesy of Media Relations.)

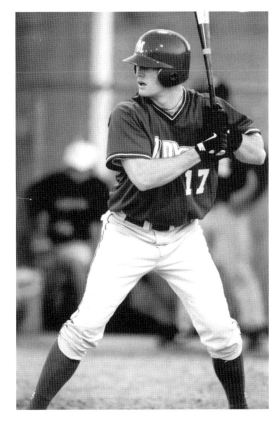

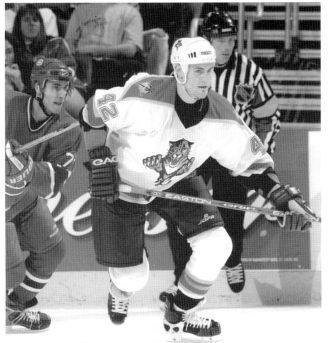

Shown here in his National Hockey League Florida Panthers uniform, Brad Norton played hockey for the minutemen from 1994 to 1998. Norton scored eight career goals, posted 47 career assists, and logged in 296 penalty minutes while in the Minuteman jersey. He was drafted by the Edmonton Oilers in the 1993 NHL draft. By 2005, he had played 111 NHL Games. (Courtesy of Media Relations.)

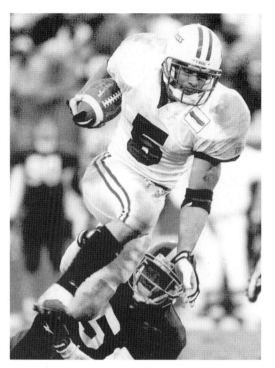

Marcel Shipp was one of the top running backs in the history of Division 1-AA football. Shipp rushed for 200 or more yards in a single game seven times as a Minuteman. He finished his career as the all-time leading rusher in the history of the A-10 Conference, with 6,250 yards. He set UMass career records for carries (1,215), rushing yards per game (130.2), points scored (378), and touchdowns scored (63). He currently plays for the NFL Arizona Cardinals. (Courtesy of Media Relations.)

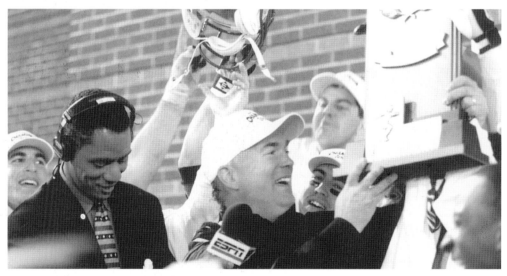

Pictured on December 19, 1998, coach Mark Whipple hoists the NCAA Division 1-AA national championship trophy in the air after his team beat Georgia Southern 55-43. When Whipple was hired as the head coach of the Minutemen on December 16, 1997, he talked about winning a national championship.

By the time the 1998 season concluded, the Minutemen had produced one of the greatest turnarounds in college football history, going from a 2-9 record the year before to a 12-3 mark and the NCAA Division I-AA national title. (Courtesy of Media Relations.)

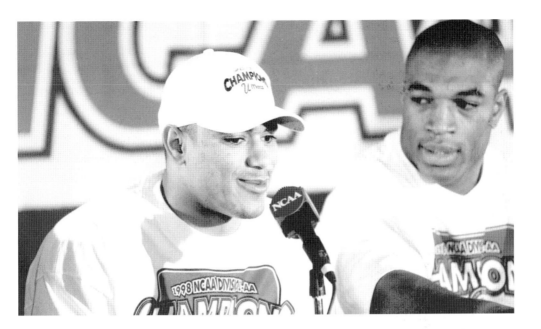

Kole Ayi (left) and Khari Samuel answer questions at the postgame press conference after winning the 1998 NCAA Division 1-AA national championship in 1998. Ayi led the defense with 16 tackles, 3 fumble recoveries (one for a touchdown), and 2 forced fumbles, and Samuel added 15 tackles and 2 forced fumbles. (Courtesy of Media Relations.)

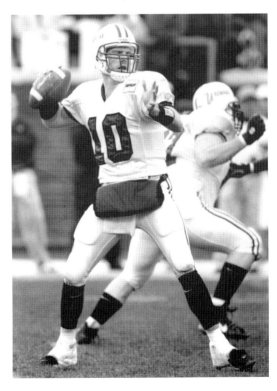

Prolific was the description of Todd Bankhead when he walked on the football field. Bankhead only played two seasons at UMass, but he owns five of the top 10 single-game passing records in school history. He set single season records for passing yards (3,919), completions (303), attempts (525), and touchdowns (34). Bankhead finished his career with school record totals of 7,018 passing yards, 561 completions, 931 attempts, and 51 touchdowns. (Courtesy of Media Relations.)

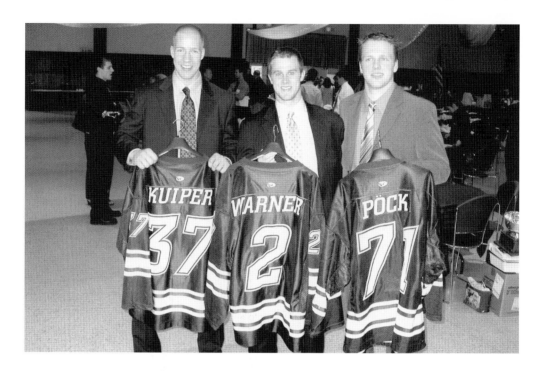

From left to right, tri-captains Nick Kuiper, Mike Warner, and Thomas Pock proudly display their 2003–2004 hockey jerseys. Each one of these players turned professional. Kuiper signed an NHL contract with the Chicago Blackhawks after the 2003–2004 season ended. Warner inked a professional hockey deal in Austria after his 2003–2004 season ended. Three days after the 2003–2004 season, Pock signed a free agent contract with the New York Rangers and scored a goal in his first NHL game.

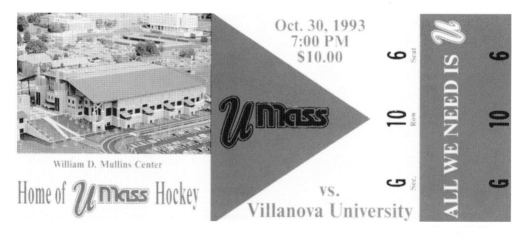

This oversized game ticket was given as a memento of the return of men's ice hockey to UMass Amherst. The hockey program had been in hiatus since the 1978–1979 season. Gov. William Weld dropped the ceremonial first puck before the game. The minutemen won their first home game in 13 years by a convincing score of 9-1 over Villanova.

Thomas Pock (2000–2004) was UMass's first ever Hobey Baker finalists. He finished tied for sixth place in all-time scoring at UMass, with 102 points. In 2004, he was named Insidecolleghockey.com's national defenseman of the year. He scored 41 points (16 goals and 25 assists) to lead all Hockey East defensemen in points in the 2003–2004 season. Pock, from Klagenfurt, Austria, played on the 2002 Olympic hockey team for his home country. He is currently in the New York Rangers organization. (Courtesy of Media Relations.)

Matt Austin came to UMass from Reading, where he played for coach Tom Kasprzak. Entering as a sophomore, he earned a starting role as an offensive lineman for the 2005 UMass football team. He worked as hard in the classroom as he did on the field: in 2005, he had a 3.5 grade point average. (Courtesy of Media Relations.)

Jason Lavorgna (No. 27) was a freshman on the 2005 baseball team. Before entering UMass, he played four years at Avon Old Farms for the Winged Beavers, coached by Robert Dowling. The senior captain lead the team to a Founders League title his senior season while posting a .535 batting average with five home runs and 35 RBIs. Lavorgna was named to the All-New England team his senior season, as well as the Winged Beaver's team MVP. (Courtesy of Karen Winger.)

UNIVERSITY OF MASSACHUSETTS MINUTEWOMEN

1976–2005

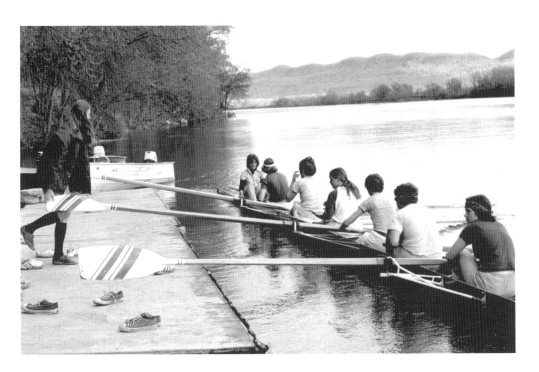

The women's crew team, shown here in 1976, is all loaded up and ready to greet the Connecticut River. Women's crew started as a varsity sport in 1972. (Courtesy of Special Collections and University Archives, W. E. B. Du Bois Library.)

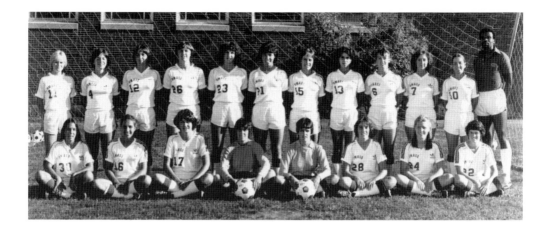

The 1980 women's varsity soccer team posted a 15-3-1 record in coach Kalenkeni "Ken" Banda's ('75) first year as head coach. From left to right are (first row) Jane Marie Lojek, Angela Caouette, Deborah Fine, Roxann Donatini, Kelly Tuller, Madeline Mangini, Kathy Hourihan, and Deanna Denault; (second row) Nina Holmstrom, Deborah Pickett, Maryann Lombardi, Natalie Prosser, Sandra Fletcher, Mary Crowley, Jackie Gaw, Polly Kaplan, Stacey Flionis, Mary Szetela, Elanie Contant, and head coach Kalekeni Banda. (Courtesy of Special Collections and University Archives, W. E. B. Du Bois Library.)

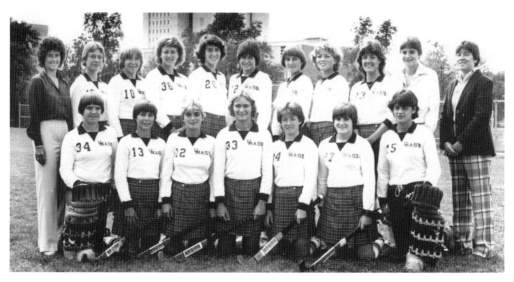

The 1981 UMass field hockey team posted a 17-1-2 record. This team produced three future UMass Hall of Famers: Carol Progulske, Judy Strong, and coach Pam Hixon. From left to right are (first row) Patty Shea (current UMass field hockey coach), Rosemarie Tudryn, Tina Coffin, Judy Strong, Sue Caples, Nancy Goode, and Mary Thomas. Identified in the second row are Hixon, Sue Packard, Patty Smith, Andrea Muccini, Judy Morgan, Carol Progulske, Patricia Stevens, Caroline Kavanaugh, Charlyn Robert, and Sandy Barbour. (Courtesy of Media Relations.)

Julie Ready currently ranks sixth in points for the Minutewomen's basketball team, with 1,406. Ready, a six-foot-two-inch center from Whitman-Hanson High School played basketball from 1977 to 1981. (Courtesy of Special Collections and University Archives, W. E. B. Du Bois Library.)

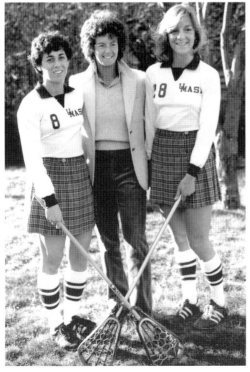

From left to right are co-captain Patricia Bossio, head coach Pam Hixon, and co-captain Lynn Herbert of the 1981 women's lacrosse team. The team went 8-5-1, with notable victories over Boston University 16-3, Dartmouth College 19-4, Boston College 12-1, and Yale University 8-7. UMass Hall of Famer Marjorie Anderson scored 47 goals, and Whitney Thayer had 34 helpers for 74 points in the 1981 season. (Courtesy of Media Relations.)

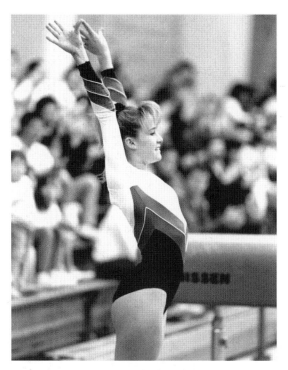

Erika Baxter of South Hadley had a great year for the UMass's women's gymnastics team in 1989. She qualified for the Northeast NCAA Regional and placed sixth in the all-around at the Atlantic 10 championships. She was voted the league MVP in 1989. (Courtesy of Media Relations.)

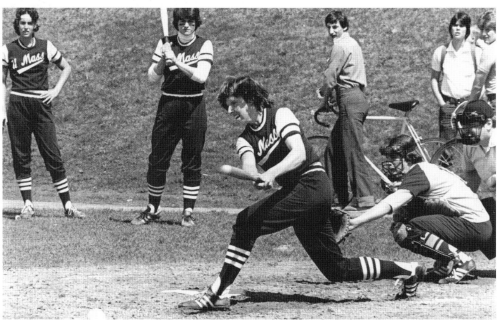

Brenda Simmons was a two-varsity sport athlete at UMass in softball and volleyball from 1979 to 1981. She was on Elaine Sortino's first team as head coach at UMass in 1980. That team went to the 1980 World Series and lost both games: 7-3 to Oregon and 2-1 to California. (Courtesy of Media Relations.)

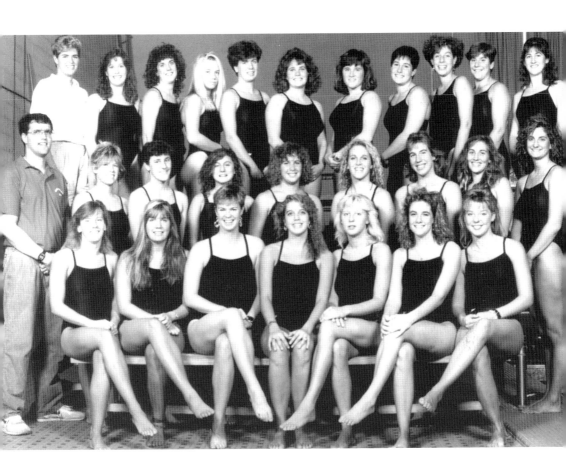

In his fifth year as head coach of the Minutewomen's swimming and diving team, Bob Newcomb (left) was crowned Coach of the Year. The team went 8-4, finished third in the New England intercollegiate swimming championships, and yielded an all-time UMass record when Michele Leary posted a 1:52.17 time in the 200-yard freestyle. She was the New England Individual Champion, with a 24.02 time in the 50-yard freestyle and a 52.62 finish in the 100-yard freestyle. The 1988–1989 team won four New England relay championship races. From left to right are (first row) Sue Gorski, Tracy Young, Michele Leary, Tonia Stafford, Kim Morin, Laurie Schwarz, and Nancy Wilkinson; (second row) Newcomb, Lynn Armstrong, Melissa McCarthy, Amy Maglio, Keira Cruz, Brooke Churchill, Amy Bloomstein, Regina Jungbluth, and Lori Carroll; (third row) assistant coach Patty Sabo, co-captain Debbie Mullen, co-captain Patty Pike, Marcia Samsel, Leslie Cromwell, Joan Flanagan, Stephanie Tuttle, Melissa Waller, Sue George, Jodi Schwartz, and Theresa Jacobs. (Courtesy of Special Collections and University Archives, W. E. B. Du Bois Library.)

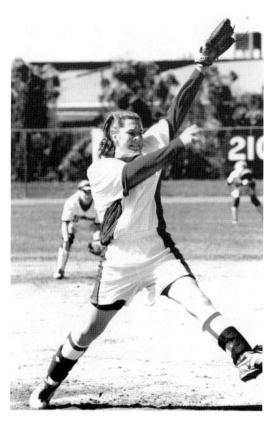

Danielle Henderson played for coach Elaine Sortino from 1996 to 1999. In her four seasons on the mound, Henderson was a three-time All-America selection, a four-time All-Atlantic 10 selection, and a four-time A-10 Tournament Most Outstanding Player. In 1999, she won the Honda Award, given annually to the nation's top softball player. She finished her career second all-time on the NCAA's strikeout list, with 1,343. She was the nation's leader in strikeouts per seven innings in both 1998 and 1999, and her 26-game winning streak ranks as the seventh-best streak in NCAA history. In her four-year career, she posted a 108-35 record in 161 appearances (964 innings), a 0.70 ERA, 72 shutouts, and 135 complete games, and she threw an astounding 14 no-hitters and three perfect games. Her No. 44 is one of only seven numbers ever to be retired from UMass athletics. (Courtesy of Media Relations.)

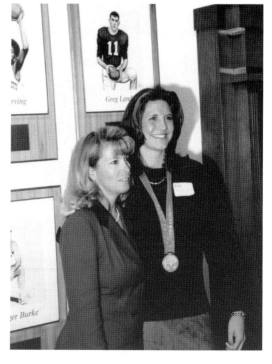

Coach Elaine Sortino (left) and Danielle Henderson pose for a photograph after Henderson returned from the Olympic Games in Sydney, Australia, with a gold medal. (Courtesy of Media Relations.)

Erin Ann O'Donnell of Reading is a member of the 2005 UMass women's cross-country team. She focused primarily on the 1,500 meters during the outdoor season and the 3,000 meters during the indoor season. She is the daughter of Ann and Paul O'Donnell, and she has two siblings, Paul and Kim. Her father and brother attended UMass; her brother, Paul, played football for the Minutemen from 1999 to 2003. (Courtesy of Media Relations.)

Liz Lovejoy of Reading is a member of the 2005 UMass women's swimming and diving team. She ranks sixth in school history in the 200-yard butterfly (2:09.62) and eighth in the 100-yard butterfly (59.35 seconds). (Courtesy of Media Relations.)

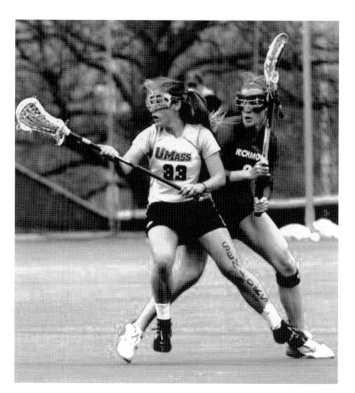

In 2005, Kathleen Typadis had 36 goals and 7 assists, totaling 43 points in 17 games. She currently holds the rookie record for scoring. (Courtesy of Media Relations.)

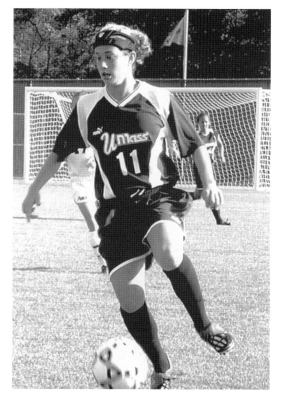

Captain Lindsey Bellini, midfielder for the 2005 women's soccer team, started all 18 games for the second consecutive season. She scored the game-winning goal vs. Marist and tallied five points in four consecutive games vs. Fordham, St. Bonaventure, Rhode Island, and Duquesne. She finished off her year with a total of two goals, three assists, and seven points. Bellini came to UMass from Webster Schroeder High School in New York. (Courtesy of Media Relations, University of Massachusetts Amherst.)

From left to right, Michelle Paciorek (No. 5), Dionne Nash (No. 10), and Cass Anderson (No. 15, with the ball) set up the spike against the University of Connecticut at the Mullins Center in 1995. (Courtesy of Media Relations.)

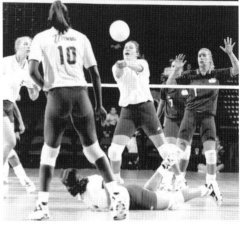

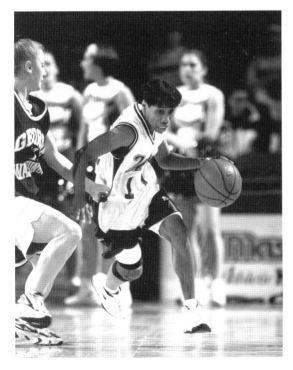

Captain Sabriya Mitchell (1994–1998) finished her career as the all-time leader in assists, with 578. She finished third all-time in steals, with 193. She was the captain of the 1997–1998 women's basketball team. (Courtesy of Media Relations.)

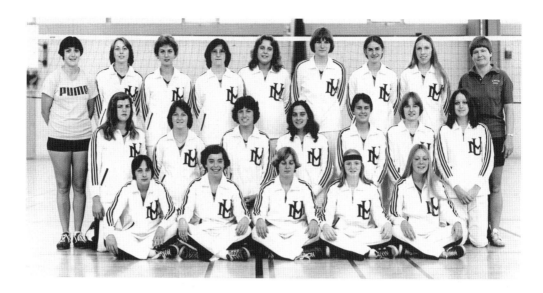

The 1977 women's varsity volleyball team sits for the annual team photograph. Women's volleyball was dropped as a varsity sport at the end of the 2002–2003 season. From left to right are (first row) Maria Minicucci, Lisa Lee, Carol Gillan, Christine Kelley, and Nancy Tate; (second row) Heidi Dickson, Patricia McGrath, Kathy Shinnick, Christine Perron, Gail Carter, Joanne Eames, and Donna Sasso; (third row) assistant coach Bonnie Buongiorne, Diane Mandragouras, Joyce Gresl, Kathy Higgins, Deborah Kuzdeba, Peggay Barber, Elizabeth Masse, Brenda Simmons, and head coach Dianne Thompson. (Courtesy of Media Relations.)

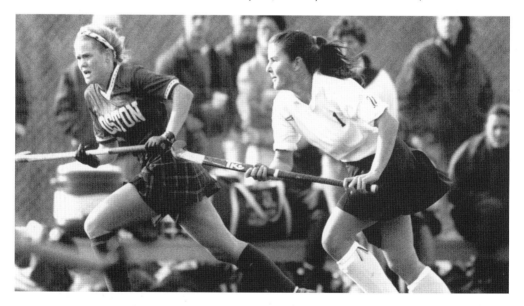

Andrea Cabral played field hockey for Pam Hixon for four seasons, from 1992 to 1995. Cabral was on the 1992 team that went 21-2-0 and advanced to the Final Four semi-final game. Her 1992 team outscored the opponents 60-13. (Courtesy of Media Relations.)

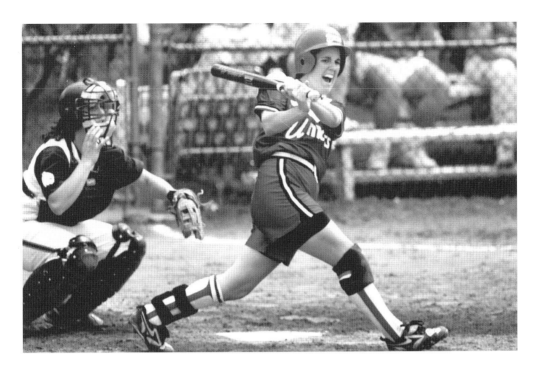

First baseman Kim Gutridge was named A-10 Rookie of the Year in 1995. She played softball for coach Elaine Sortino from 1995 to 1998. Gutridge led the Minutewomen to four consecutive Atlantic 10 championships and back-to-back World Series appearances. In her senior campaign, she hit .404, ranking her sixth on UMass's all-time chart, and drove in 45 RBIs, a single-season UMass record. (Courtesy of Media Relations.)

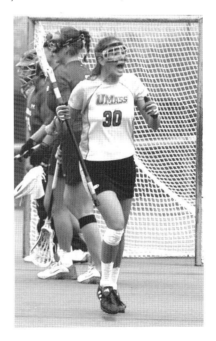

Jeannette Villapiano is a sophomore on the UMass women's lacrosse team. In the 2005 season, she netted eight goals and two assists for 10 points. She came from Ocean Township High School in New Jersey.

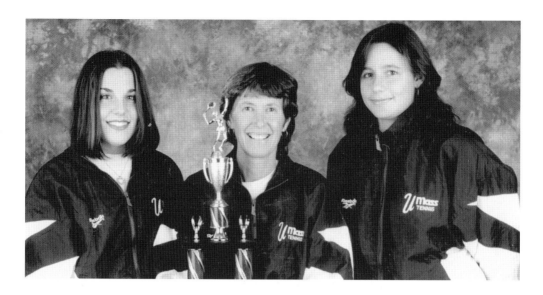

From left to right, Liz Durant, coach Judy Dixon, and Liesl Sitton pose with the trophy for winning the 1996 New England doubles championship. Women's tennis started intercollegiate competition in the 1975–1976 season. Dixon, 133-113 at UMass, started coaching the Minutewomen in the 1992–1993 season. (Courtesy of Media Relations.)

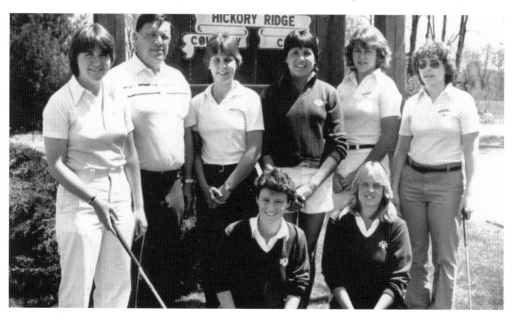

The 1981 women's golf team poses in front of the Hickory Ridge Golf Club with coach Jack Leaman. From left to right, team members are (first row) Jane McCarthy and Barbara Spilewski; (second row) Jane Egan, Leaman, Susan McCrea, Marlene Susienka, Nola Eddy, and Linda Bissonnette. (Courtesy of Special Collections and University Archives, W. E. B. Du Bois Library.)

UNIVERSITY OF MASSACHUSETTS HALL OF FAME

Marjorie Anderson '82 played attack for the lacrosse team and forward on the soccer team, earning a total of seven letters from 1978 to 1982. In 1982, she was the captain of the lacrosse team that captured UMass's first NCAA title. She led the team to a 10-0 record in 1982 and was named team MVP. On the soccer team, she totaled 71 career points on 30 goals and 11 assists. In 1978, she scored 12 goals and led the Minutewomen to an overall record of 15-0-1, the only undefeated season in school history. (Courtesy of Media Relations.)

Holly Aprile '93 finished her softball career with a then school record 77 victories. She was a four-time A-10 All-Conference performer, a three-time A-10 Player of the Year, and a third team All-America selection in 1982. As a senior, she went 11-3 with a 1.19 ERA and hit .333. She was the A-10 Rookie of the Year in 1989, A-10 Pitcher of the Year in 1992, A-10 Tournament MVP in 1990, and the A-10 Tournament's outstanding pitcher in both 1989 and 1992. She was named to both the All-Northeast Region and All-New England teams on two occasions and was a member of the 1992 ECAC All-Star team. In the classroom, she was named to the 1992 A-10 Academic All-Conference team. She led UMass to four Atlantic 10 titles, three NCAA tournament appearances, and the school's first NCAA College World Series trip in 1992. (Courtesy of Media Relations.)

Kalekeni "Ken" Banda '75, head coach of women's soccer from 1980 through 1987, compiled a 120-25-10 (.806) record. He led the Minutewomen to six consecutive NCAA appearances, including five straight trips to the Final Four. He left the university in 1987 after coaching 20 All-America selections and 31 All-New England selections. A native of Malawi, Africa, Banda also served as women's track and field coach for eight years. (Courtesy of Media Relations.)

As a junior in the 1954–1955 basketball season, David Bartley '56 averaged 3.4 points, 3.1 rebounds, and 1.8 assists. As a senior, from 1955 to 1956, he averaged 8.7 points, 6.1 rebounds, and 4.4 assists. That season, UMass finished 17-6 overall and 5-1 in the Yankee Conference. Bartley's career numbers were 6.5 points per game, 4.8 rebounds, and 3.3 assists. Bartley is the only UMass graduate to become the speaker of the Massachusetts House of Representatives, serving seven years. (Courtesy of Media Relations.)

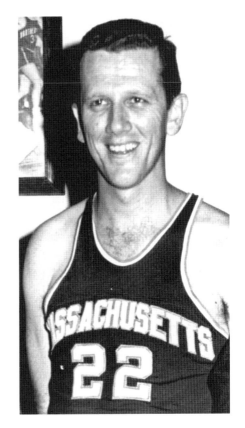

A standout soccer player at UMass from 1984 to 1987, Debbie Belkin '88 was a three-time first-team All-America selection and All-New England selection (1985–1987). Despite playing in the backfield, she stands 10th on the UMass all-time points list (70), 10th in career goals (25), ninth in career assists (20), and 10th in single-season goals (11). She was chosen as the Final Four Defensive MVP in 1987. (Courtesy of Media Relations.)

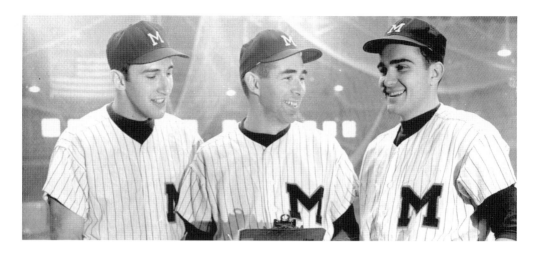

From left to right, Ted Mareno, coach Dick Bergquist '57, and Carl Boteze discuss the upcoming game in 1967. A member of the American Baseball Coaches Association (ABCA) Hall of Fame, Bergquist (1967–1987) is the all-time winningest coach in UMass baseball history. He compiled a 392-321-5 record in 21 seasons at the helm of the UMass program, leading UMass to seven Yankee Conference championships (1967, 1969, 1971, 1973, and 1978–1980), two New England titles (1969 and 1978), one Atlantic 10 championship (1980), five NCAA tournament appearances (1967, 1969, 1971, 1973, and 1978), and one trip to the College World Series (1969). (Courtesy of Media Relations.)

Kristen Bowsher '88 was a four-year letter winner for the UMass women's soccer team from 1984 to 1987, earning NSCAA All-America honors as a midfielder in each of her four seasons. She helped lead the Minutewomen to four consecutive NCAA tournament Final Four appearances from 1984 to 1987, including 1987, when the team lost to North Carolina 1-0 in the national championship game, and won a school record 20 games. Bowsher was a three-time NCAA All-Tournament team selection from 1985 to 1987, leading UMass to an overall record of 65-9-4 during her four years. (Courtesy of Media Relations.)

Dick Bresciani '60 (left) and Jim Mulcahy pose at Bresciani's Hall of Fame induction in 2002. Bresciani's association with UMass athletics dates to his undergraduate days in Amherst, when he worked in the school's sports information office for College Sports Information Directors of America (CoSIDA) Hall of Famer Dick Page and covered the Redmen for the *Massachusetts Daily Collegian*. In 1968, he and former athletic director Warren McGuirk established the UMass Athletic Hall of Fame. In November 1996, Bresciani became the Red Sox's vice president of public affairs and club historian. (Courtesy of Media Relations.)

Jeannine Burger '75 was the first female All-American in school history and was the first woman to be inducted into the UMass Hall of Fame (in 1981). Burger earned All-America honors in each of her four years. She led her team to the 1973 national championship during her sophomore year, the first national title in school history. She is married to another member of the UMass Athletic Hall of Fame, Greg Landry. (Courtesy of Media Relations, University of Massachusetts Amherst.)

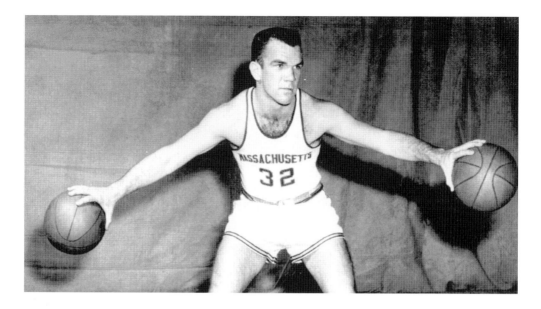

George "Trigger" Burke '56 is the man for whom the UMass Athletic Hall of Fame is named. Burke played basketball for two years at UMass in the 1950s. A 1956 second-team All-America selection, he was named first-team All-East, first-team All-New England, first-team All-Yankee Conference, and first-team All-Boston Garden. He remains one of only four former Minutemen to have his jersey number retired, and his No. 32, shared with fellow UMass legend Julius Erving, hangs from the rafters of the Mullins Center. (Courtesy of Media Relations.)

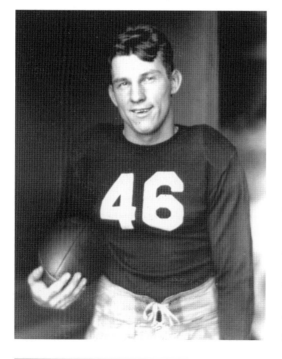

Lou Bush '34 was a three-time letter winner in football from 1931 to 1933. He was phenomenal in 1931 and 1932, scoring 39 touchdowns over that span, an average of over two per game. In his first year of collegiate football in 1931, he led the nation in touchdowns with 20. While at UMass, Bush also played baseball and basketball and was a member of the school's only undefeated basketball team (12-0) in 1934. He was a charter member of the UMass Hall of Fame; he was inducted in 1969. He is on the cover of this book, wearing his No. 46. (Courtesy of Media Relations.)

A three-year member of both the hockey and baseball teams, George "Sugar" Cain '33 was one of the great players of early UMass hockey history. Known for "raising Cain," he helped the 1931 hockey team to a 9-3 mark. In 1932, when UMass downed the then Connecticut Aggies 17-0, Cain led the way with five goals. His 1933 team finished 5-2-1. Cain was also an outstanding pitcher for the UMass baseball team, leading the 1932 team to a 9-6 record. (Courtesy of Media Relations.)

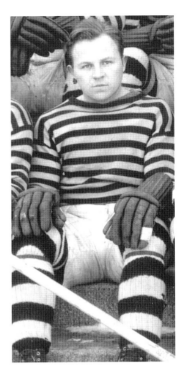

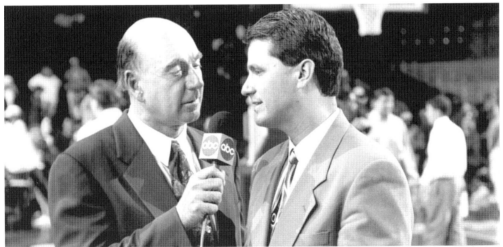

John Calipari (right), seen here with ABC analyst Dick Vitale, led the UMass men's basketball team to an overall record of 193-71 in his eight seasons as head coach from 1988 to 1996. His .731 career-winning percentage remains the best in school history, and he ranks second all time at UMass in victories, with 193. Calipari led the Minutemen to five straight NCAA tournament appearances from 1992 to 1996 after UMass had gone to the NCAAs only once in the first 81 years of the program. His Minutemen made the Atlantic 10's first and only Final Four appearance during the 1996 season, during which they went 35-2 overall and spent 10 weeks ranked No. 1 in the nation. (Courtesy of Media Relations.)

A three-year letter winner for UMass from 1951 to 1953, Tony Chambers '54 earned All-America status in 1952, making 36 catches for 455 yards and seven touchdowns. Chambers teamed with fellow UMass Athletic Hall of Famer Noel Reebenacker on what remains one of the most prolific passing tandems in UMass history. Chambers was named All-Yankee Conference and All-New England in addition to his All-America honors. (Courtesy of Media Relations.)

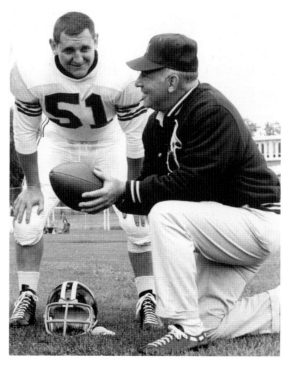

Bernie Dallas '66 (No. 51) is shown with coach Vic Fusia. Dallas was a two-year letter winner in football for UMass in 1963 and 1965. He also served as team captain during his senior season. As a sophomore, he played offensive center and defensive line and was a spark plug on the undefeated 8-0-1 team that captured the school's first outright Yankee Conference football title. An automobile accident took Dallas's life on April 29, 1968. (Courtesy of Media Relations.)

Gary DiSarcina, one of the top shortstops ever from UMass, parlayed three outstanding collegiate seasons into a 12-year major-league career with the Anaheim Angels. While at UMass, he earned first-team All-Atlantic 10 honors and was named first-team All-New England selection twice. DiSarcina led UMass to an overall record of 36-16 during his junior season in 1988, when he hit .366, shattering the school single-season record for victories at the time. He struck out only 10 times in 202 at bats. In 1989, following his junior season, DiSarcina was drafted by the Angels in the sixth round and became their starting shortstop in 1992.

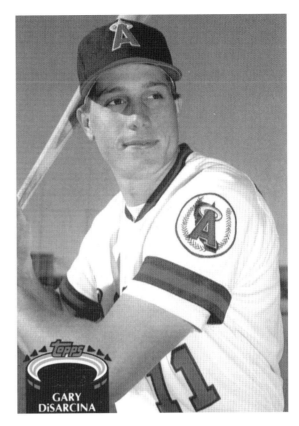

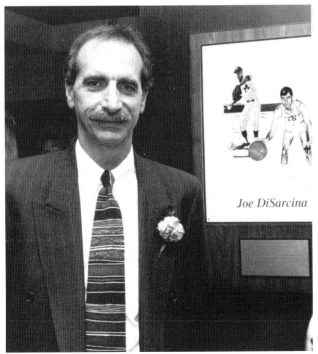

Joe DiSarcina

A two-sport standout athlete, Joe DiSarcina '69 competed for both the UMass basketball and baseball teams from 1966 to 1969. In 1969, DiSarcina was a key member of the UMass team that captured the Yankee Conference championship and upset No. 1 Southern Illinois 2-0 in the College World Series. As a guard on the basketball team, DiSarcina set several school records, including assists in a game (15), a season (167), and a career (431). (Courtesy of Media Relations.)

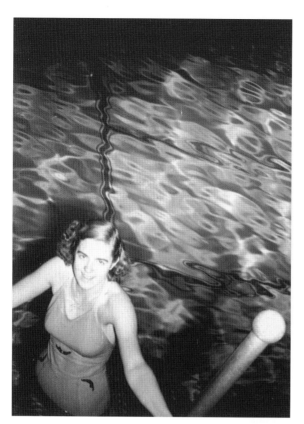

Dorothy Donnelly (Leonard) '41, despite attending UMass at a time when a women's swimming team was nonexistent, went on to become a world-class swimmer. She was a member of the U.S. Olympic team in 1940 and competed in the 100-meter freestyle and the 400-meter freestyle, and as a member of the 400-meter freestyle relay. A native of Worcester, she reached her peak during the war years, when no games were held. She continued to swim until her death in 2000. (Courtesy of Special Collections and University Archives, W. E. B. Du Bois Library.)

Megan Donnelly '86 finished her UMass career as the only four-time first-team All-America selection in school history. Donnelly won the 1986 Broderick Award, which is presented to the nation's top field hockey athlete. She was a 1983 NCAA All-Tournament selection and was named to the NCAA All-Decade team (1981–1991). Donnelly was a member of four consecutive NCAA tournament teams, including the 1982 team that advanced to the Final Four. (Courtesy of Media Relations.)

A two-sport star, Ray Ellerbrook '70 competed on the UMass baseball and basketball teams from 1967 to 1970. A two-time All-Yankee Conference selection in basketball (1969 and 1970), Ellerbrook was a third-team All-New England selection in 1968–1969. He was also a two-time All-Yankee Conference selection in baseball (1969 and 1970) and an honorable mention All-New England and All-Northeast second-team selection in 1970. A member of the basketball team that captured three straight Yankee Conference titles (1968–1970), Ellerbrook was the captain of the 1969–1970 squad that advanced to the National Invitation Tournament for the first time in school history. (Courtesy of Media Relations.)

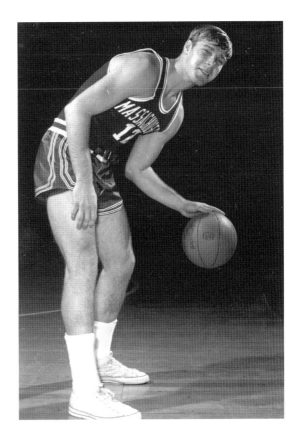

After lettering in football and basketball for three years (1927–1929), Frederick "Fritz" Ellert '30 later went on to coach the basketball team for three seasons (1930–1931, 1932–1933, and 1940–1941), posting an 18-16 mark. During his playing days, Ellert was a two-time captain of the UMass basketball team, guiding the 1929–1930 squad to an 11-3 mark. As a football player, he earned a spot on the 1929 All-New England team. Upon completion of his collegiate athletic career, he became a member of the UMass faculty. He retired from teaching in 1970. (Courtesy of Media Relations.)

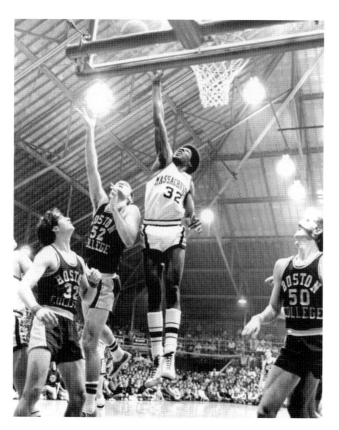

Unquestionably the greatest known athlete in UMass history, Julius Erving '86, known to the world simply as Dr. J, played basketball for two seasons under legendary head coach and fellow UMass Hall of Famer Jack Leaman from 1969 to 1971. During his two seasons, Erving averaged an incredible 26.3 points and 20.2 rebounds per contest. He turned professional following his junior year but not before leading UMass to two Yankee Conference titles and its first two appearances in the National Invitation Tournament (NIT). (Courtesy of Special Collections and University Archives, W. E. B. Du Bois Library.)

Mike Flanagan '75 lettered for the UMass baseball team in 1972 and 1973, earning first-team All-Yankee Conference and first-team All-New England honors in 1973 before turning professional. Flanagan went 9-1, with a 1.52 ERA and 91 strikeouts in 1973, to lead the team in all three categories. Flanagan went on to pitch 18 seasons in the major leagues with the Orioles (1975–1987, 1991–1992) and Toronto Blue Jays (1987–1990). He won the 1979 American League Cy Young Award for the Orioles, going 23-9, with 190 strikeouts and a 3.08 ERA in 265 2/3 innings. (Courtesy of Media Relations.)

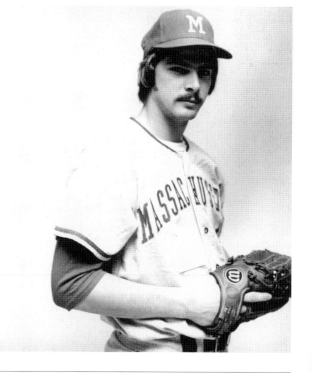

Bob Foote '62 earned three letters as an offensive and defensive tackle on the UMass football team in 1958, 1960, and 1961. He was a two-time ECAC Player of the Week selection in his senior season. Foote recovered a fourth-quarter fumble in midair and returned it six yards for a touchdown in UMass's 25-0 win over Rhode Island in 1961. (Courtesy of Media Relations.)

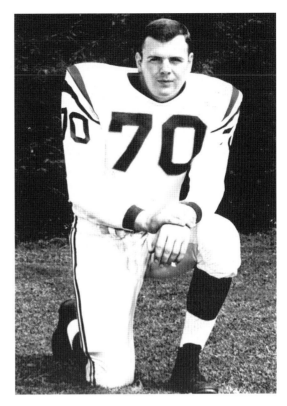

Vic Fusia (left), with Pres. John Lederle, accepts the runner-up trophy at the 1964 Tangerine Bowl. Fusia was the head coach of the UMass football team from 1961 to 1970, leading UMass to five Yankee Conference titles. His Redmen had their best season in 1964, when he guided them to the school's first-ever postseason appearance—the Tangerine Bowl—where UMass lost a heartbreaking 14-13 decision to East Carolina. Fusia compiled a 59-32-2 record (.645 winning percentage) in his 10 seasons and still reigns as the winningest coach in school history more than 25 years after his retirement. (Courtesy of Media Relations.)

A member of the Lacrosse Hall of Fame, Dick Garber coached at UMass from 1955 to 1990. Garber compiled a 300-142-3 overall record in 36 seasons at UMass and is the winningest coach in college lacrosse history. Garber led UMass to nine NCAA tournament appearances and 13 New England championships. A three-time national Coach of the Year (1969, 1976, and 1989) and 14-time New England Coach of the Year, Garber served as head coach of the North All-Stars at the North-South game twice (1965 and 1983). Upper Boyden Field was renamed Richard F. Garber Field in his honor. (Courtesy of Media Relations.)

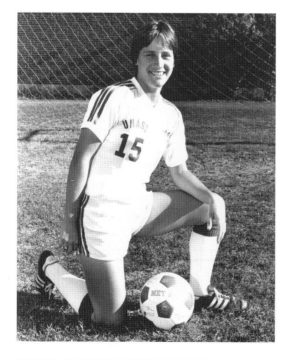

An All-American in both soccer and softball, Jacqueline Gaw '83 earned four letters in both sports from 1979 to 1983. A two-time All-America selection in softball and a soccer All-America selection in 1982, Gaw was UMass's first first-team All-America pick in softball. She was a member of the 1980 softball team that advanced to the AIAW National Tournament and the first women's soccer team to advance to the NCAA tournament (1982). (Courtesy of Media Relations.)

A two-year letter winner in football, Harold "Kid" Gore '13 played quarterback for the 1911 and 1912 UMass football teams. Upon his graduation in 1913, Gore went on to become an assistant in the physical education department before becoming a full-time professor in 1916. He was instrumental in reinstating the school's basketball program in 1916 after an eight-year hiatus, assuming the head coaching duties. He served as head football coach from 1919 to 1927. (Courtesy of Special Collections and University Archives, W. E. B. Du Bois Library.)

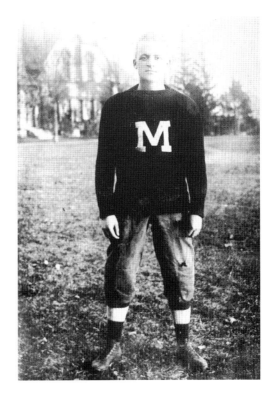

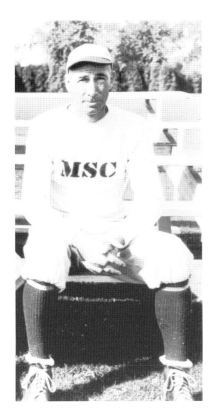

A letter winner in three sports at UMass (baseball, basketball, and football), Emory Grayson '17 won eight letters during his career and is regarded as one of the most versatile athletes in UMass history. He also competed in hockey and track. He played as a backup halfback on the football team during his freshman year, alternating between the backfield and the end position. In his junior year, he played in the first game on the "new" Alumni Field, where the Whitmore Administration Building now stands. (Courtesy of Media Relations.)

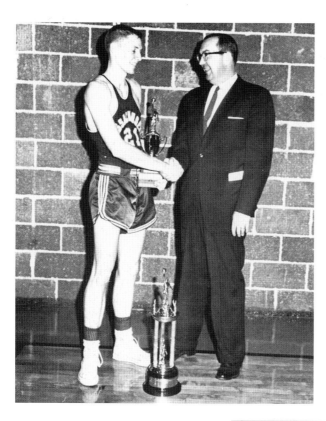

Doug Grutchfield '61 (left) shakes hands with Warren McGuirk after winning the Yankee Conference MVP Trophy in 1961. Grutchfield was a three-year letterman for coaches Robert T. Curran and Matthew Zunic and set 13 school records during his career from 1959 to 1961. He tallied a then school-record 1,257 points in just 74 games for the Maroon and White, a figure that currently ranks as the 15th-best mark in school history. (Courtesy of Media Relations.)

Pam Hixon ranks as not only one of UMass's greatest coaches ever but also one of field hockey's finest. The fifth-winningest coach in collegiate field hockey history, Hixon directed the Massachusetts field hockey program for 17 seasons (1978–1993 and 1996) and led her team to postseason play every year. She took the Minutewomen to 14 NCAA tournaments, one AIAW tournament, and a pair of EAIAW tournaments. Her teams made four NCAA Final Four appearances, finishing second in 1981. She led the school to its first women's NCAA national championship in school history in 1982. (Courtesy of Media Relations.)

A three-year letter winner in football and lacrosse at UMass, Richard Hoss '62 shined under legendary lacrosse mentor Dick Garber from 1959 to 1961, earning honorable mention All-America honors as a midfielder in 1960 and 1961. In his senior season, Hoss served as team captain. He led the nation in 1960 with 37 goals, and his 46 points that year led all New England midfielders. As a football player, Hoss was the team's starting fullback and punter. (Courtesy of Media Relations.)

A three-time NSCAA All-America midfielder (1988, 1989, and 1990), April Kater '91 earned the 1990 Hermann Trophy, given annually to the nation's top female collegiate soccer player. A four-year letter winner for the Minutewomen's soccer team from 1987 to 1990, she was a three-time All-New England selection who earned 1987 Soccer America Freshman of the Year honors and then garnered first-team All-America awards in each of her final three seasons. (Courtesy of Media Relations.)

Patrick Keenan '73 earned three letters in ice hockey at UMass (1970–1973) and was a two-time first-team All-America selection for coach Jack Canniff. Keenan still ranks as the all-time leading scorer in school history, with 180 points. He also holds school records for goals scored (105) and ranks third in assists (75). In addition to his career marks, Keenan holds the three best single-season marks for points and goals scored (65 points and 43 goals in 1972–1973, 59 points and 43 goals in 1971–1972, and 56 points and 28 goals in 1970–1971). (Courtesy of Media Relations.)

Warren McGuirk (left) presents Russell Kidd '56 with the Joe Lojko Award for the best senior athlete in 1956. Kidd earned six letters during his career as a UMass student-athlete from 1954 to 1956. He earned three letters in hockey (1954–1956), two in football (1954–1955), and one in lacrosse (1956). Kidd served as the men's soccer coach at UMass from 1975 to 1981. (Courtesy of Media Relations.)

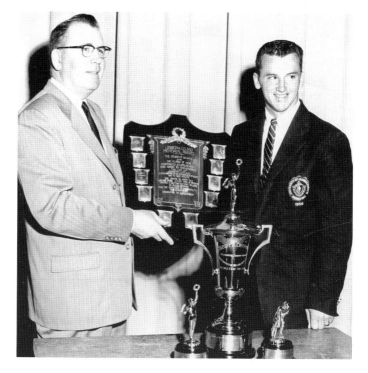

Bruce Kimball '79 earned three letters as a member of the UMass football team from 1976 to 1978 and earned first-team all-America honors at guard in both 1977 and 1978. He served as captain in 1978 and earned All-Yankee Conference honors in both 1977 and 1978, when the team won back-to-back conference titles. A member of the 50th anniversary Yankee Conference team, Kimball also helped UMass to the 1977 NCAA Division II playoffs. (Courtesy of Media Relations.)

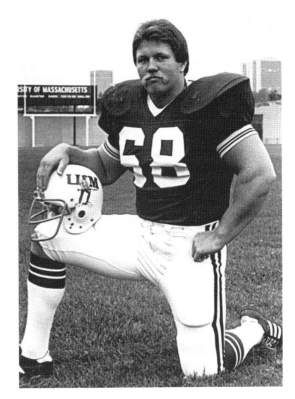

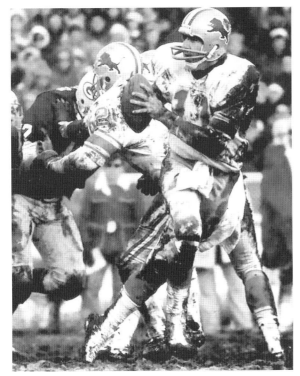

Dubbed the greatest quarterback in UMass history, Greg Landry '68 earned three letters in football from 1965 to 1967. Behind his golden arm and running ability, UMass won two Yankee Conference Beanpots in three years. Landry led the team in passing all three years and led in both rushing and scoring in 1965 and 1967. His quarterback efficiency rating of 145.4 in 1965 is still the school record. He played quarterback for the Detroit Lions from 1968 to 1978. He is one of six Minutemen named to the Yankee Conference 50th anniversary team. (Courtesy of the Detroit Lions.)

A star guard on the basketball squad and a shortstop on the baseball team between 1957 and 1959, Ned Larkin '59 earned first-team All-Yankee Conference honors as a senior in 1958–1959 and honorable mention recognition as a sophomore. He led UMass in scoring as a senior (13.5 points per game), was third as a junior (9.4 points per game), and second as a sophomore (12.9 points per game). He was selected to play in the Hall of Fame All-Star game following his senior season, which pitted New England's finest against Boston's best. (Courtesy of Media Relations.)

Compiling a career record of 217-126 in 13 seasons, Jack Leaman served as head coach of men's basketball at UMass from 1966 to 1979. The all-time winningest coach in school history, Leaman guided UMass to eight Yankee Conference titles in nine seasons (1968–1971, 1973–1976) and six NIT appearances (1970–1971, 1973–1975, and 1977). A two-time New England Coach of the Year, Leaman coached Basketball Hall of Famer Julius Erving, Louisville head coach Rick Pitino, Boston College head coach Al Skinner, and UMass Athletic Hall of Famers Bill Tindall and Joe DiSarcina. (Courtesy of Media Relations.)

A four-year letter winner on the UMass lacrosse team from 1986 to 1989, Sal LoCascio '89 earned USILA All-America honors as goalie in each of his four seasons. A three-time New England Player of the Year selection and four-time All-New England honoree, LoCascio holds the all-time NCAA record for career saves, with 931. He was the starting goalie on four consecutive NCAA tournaments and New England championship teams from 1986 to 1989, including the 1989 team that was the first UMass team to advance to the quarterfinals of the NCAA tournament. LoCascio led the team in saves all four seasons, and his four single-season save totals are the four best in UMass history, including a record 271 in 1987. (Courtesy of Media Relations.)

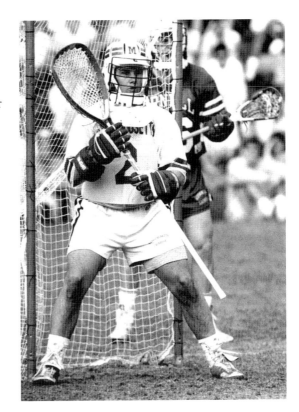

Born in Poland in 1911, Joseph Lojko '34 moved to Northampton soon afterward. He went on to letter in football, basketball, and baseball at UMass. He won three letters in both football and basketball and two in baseball. The basketball team was 28-12 in his three years, and the football team compiled a three-year mark of 19-6-1. His 1933 baseball team finished 7-5. Tragically, Lojko was killed in an automobile accident on April 27, 1934, just two months shy of his graduation day. (Courtesy of Media Relations.)

Earl Lorden, for whom UMass's varsity baseball field is named, coached baseball at UMass from 1947 to 1966. He compiled a career record of 193-147-3 during his tenure and led the 1954 team to the District I title and a berth in the College World Series. In 1970, he was elected to the Massachusetts Baseball Coaches Association Hall of Fame, and in 1971, the university dedicated the baseball field in his honor. (Courtesy of Media Relations.)

The founder of the school's men's and women's ski programs, Bill MacConnell '41 led the Minutemen from 1961 to 2001 and the women's program from its inception in 1976 through the 2001 campaign. All told, his teams captured 30 divisional titles—18 men's and 12 women's. From 1968 to 1986, a span of 18 straight seasons, MacConnell's program won its division every year. Since 1986, it has been either second or third in its division each year. (Courtesy of Media Relations.)

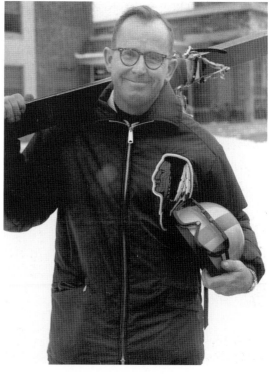

Dick MacPherson stands with his two captains Dennis Keating (left) and John Hulecki in 1971. MacPherson served as the head coach of the UMass football program for seven seasons, from 1971 to 1977, leading the team to four Yankee Conference championships (1971, 1972, 1974, and 1977). During his seven seasons, MacPherson recorded a 45-27-1 record and led UMass to its only postseason bowl victory, as his 1972 squad defeated the University of California at Davis 35-14 in the 1972 Boardwalk Bowl. MacPherson's 45 victories rank third all-time in UMass history. (Courtesy of Media Relations.)

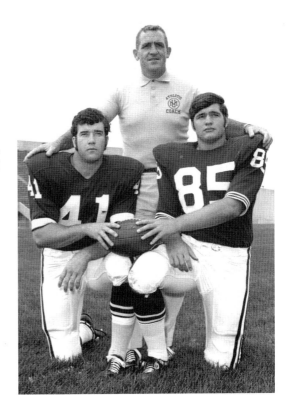

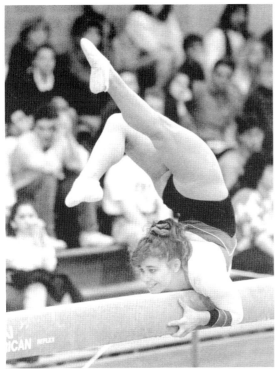

The only student-athlete in school history to claim an NCAA individual championship in any sport, Tammy Marshall '93 won the 1992 NCAA vault title with a score of 9.8125 and claimed 1993 NCAA floor exercise championship with a perfect 10 on the event. A five-time Atlantic 10 champion, she won the all-around in 1990 (37.800), the balance beam (9.700) and all-around (38.300) in 1991, and the vault (9.900) and balance beam (9.800) in 1993. She is one of only two gymnasts in school history ever to score a perfect 10 in any event. (Courtesy of Media Relations.)

Ed McAleney '76, a four-year letter winner for Dick MacPherson's football team and a member of two Yankee Conference championship football teams, served as team captain in both 1974 and 1975. A three-time first-team All-Yankee Conference selection and three-time All New England (1972–1973, and 1975) selection at defensive end, McAleney earned first-team All-America honors as a senior in 1975. He was one of six former UMass players named to the Yankee Conference All-Time 50th anniversary team in 1996. (Courtesy of Media Relations.)

In the days when hockey was played on the frozen Campus Pond, Justin "Jerry" McCarthy '21 developed into one of the all-time Aggie greats. He played right wing for four years, leading UMass to a 12-8-3 mark. He captained the 1921 team and was also a member of the 1924 silver medal U.S. Olympic team that traveled to France. He also lettered as a shortstop for the baseball team in 1919 and was a member of the school's football team.

Jim McCoy '97 was a cornerstone in the rebirth of the UMass basketball fortunes under coach John Calipari and finished his standout career as the school's all-time leading scorer, with 2,374 points. A four-year letterman for John Calipari, the sharpshooting McCoy was a four-time All-Atlantic 10 selection and three-time All-District performer. He was the first Minuteman ever to earn first-team All-Atlantic 10 recognition. He still holds UMass career marks for points scored (2,374), field goals made (876) and attempted (2,013), and games started (121). (Courtesy of Media Relations.)

Warren McGuirk served as dean of the School of Physical Education and director of athletics at UMass for over three decades. During his tenure as an administrator, coach, and teacher, he made improvements in facilities, curriculum, and intramural programs. McGuirk was instrumental in the development and construction of the Women's Physical Education Building (1958), the Boyden Building (1963), and the football stadium—now Warren McGuirk Alumni Stadium (1966). (Courtesy of Media Relations.)

Brian McIver '91 (fourth row, fourth from the left) is one of the most decorated swimmers in school history, having captured 10 New England individual crowns and a pair of Eastern Intercollegiate titles. He was also a member of 10 Massachusetts relay teams that captured New England titles during his career and set three individual school records, one of which still stands today. (Courtesy of Media Relations.)

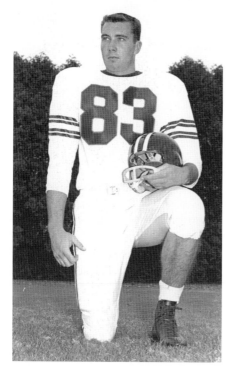

A three-time letter winner in football from 1963 to 1965, Bob Meers '66 earned All-Yankee Conference and All-New England honors in each of his three seasons as tight end. At the time of his graduation, Meers shared the record for most receptions in one game (9), was first in most career receptions (82), first in receptions in a season (39), second in receiving yards in a game (146 vs. University of New Hampshire in 1965) and in a career (1,104), and second in highest average yards per game in a season (59.8) and in a career (40.9). He still ranks in the top 10 in all of these categories and is fourth in all-time career receptions. Meers, a tri-captain of the 1965 team, was a seventh-round pick of the Minnesota Vikings in 1966. (Courtesy of Media Relations.)

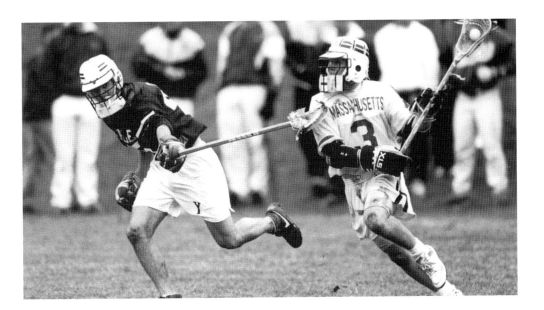

Mark Millon '94 is considered one of the greatest players in the history of lacrosse and was a four-year letter winner for the Minutemen from 1990 to 1993. He earned first-team All-America honors in 1992 and 1993, becoming the first UMass player to be selected to the first team twice. He was also an honorable mention All-America selection in 1991 and earned All-New England honors three times. During his four-year career, Millon totaled 213 points on 155 goals and 58 assists, making him the fourth leading scorer in UMass history. (Courtesy of Media Relations.)

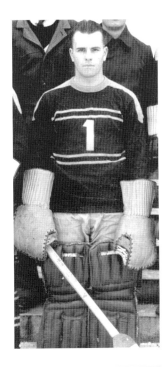

Clifton Morey '39 won nine letters at UMass in the late 1930s in football, hockey, and baseball and served as captain of the hockey and football teams in his senior year. He played end in football, goalie in hockey, and center field in baseball. His baseball teams were a combined 33-9 in his three years. As a goalie for the UMass hockey team in 1939, Morey was spectacular in the 3-3 tie with West Point on the Campus Pond—although the club struggled to a 0-4-1 start. (Courtesy of Media Relations.)

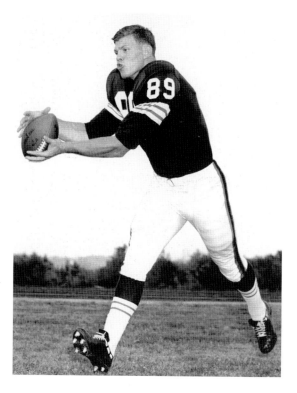

One of the most versatile athletes ever to play for UMass, Milt Morin '66 lettered in football for three years from 1963 to 1965. He was a three-time All-America selection and set a then school record of career receiving yards, with 1,151. He was part of two Yankee Conference championship teams under Vic Fusia, helping UMass compile an impressive 23-4-1 record during his three years. Morin was also the New England heavyweight wrestling champion in 1965 and played lacrosse for Dick Garber's stickmen. A first-round draft pick by the Cleveland Browns in the 1966 NFL draft, he went on to play 10 seasons for the Browns. He played in three Pro Bowls (1966, 1968, and 1969). (Courtesy of Media Relations.)

Laura O'Neil '81 was a field hockey and lacrosse player for the Minutewomen from 1977 to 1980 and earned a total of six letters. She earned first-team All-America honors as a senior in both sports. In field hockey, she still ranks among the school's all-time leaders in career points (87, sixth-tie), goals (34, eighth tie), and assists (19, ninth), and single-season points (57 in 1979, fourth), goals (20 in 1979, seventh-tie), and assists (17 in 1979, sixth). At the time of her graduation, she ranked first in single-season assists and second in career points, single-season points, single-season goals, and third in career assists. (Courtesy of Media Relations.)

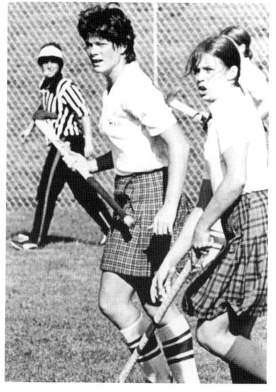

Garry Pearson '83 was a two-time first-team All-America selection (1981–1982) who earned four letters in football from 1979 to 1982 and demolished every school rushing record. He set 12 UMass records during his career: career yards (3,859), single-season (1,632 in 1982) and single-game yards (288 vs. American International College in 1982), single-game carries (45 vs. American International College in 1982), single-season carries (312 in 1982), career carries (808), single-season touchdowns (15 in 1980), career touchdowns (35), single-season rushing yards per game (148.3 in 1982), career all-purpose yards (5,277), season all-purpose yards per game (175.7 in 1981), career all-purpose yards per game (131.9), and single-game all-purpose yards (319 vs. American International College in 1982). (Courtesy of Media Relations.)

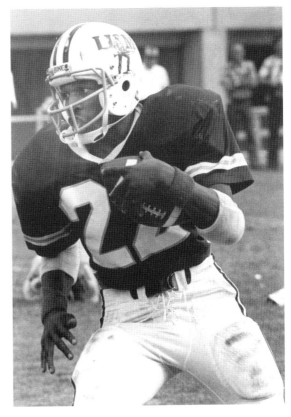

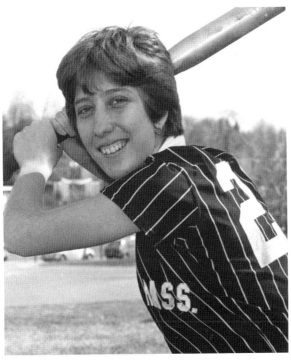

A two-sport star in both basketball and softball, Sue Peters '80 was a Co-SIDA Academic Hall of Fame nominee. She set a UMass single-season record for both points (587) and scoring average (23.4 points per game). Her 131 free throws made also set a school record, as did her 493 field goals attempted. She remains the all-time UMass career-scoring leader, with 1,858 career points, and her 20.0 points per game average is also the best in school history. (Courtesy of Media Relations.)

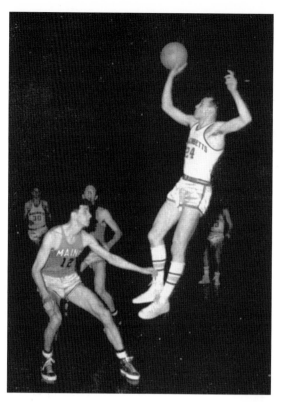

Bill Prevey '52 was a three-year letter winner for the UMass basketball team (1949–1952) and captained the 1951–1952 squad. A first-team All-Yankee Conference and All-New England selection as a senior in 1952, Prevey totaled 836 career points during his career, a mark which was the best in school history at that time and stood as the school record until Jack Foley broke it five years later en route to becoming the first 1,000-point scorer in school history. As a senior, Prevey averaged 22.6 points per game, a mark which ranked fifth nationally among small colleges and still ranks as the fourth-best single-season mark in school history. (Courtesy of Media Relations.)

A two-sport star in field hockey and lacrosse from 1980 to 1984, Carol Progulske (Doak) '84 was a two-time first-team All-America selection in both sports. A College Field Hockey Coaches Association All-America selection in 1982 and a Mitchell and Ness All-America selection in 1983, she was also a two-time Brine All-America selection in lacrosse (1983–1984). A member of the national runner-up field hockey team in 1981, as well as the Final Four team in 1983, she played on UMass's only three lacrosse teams to make NCAA tournament appearances. She was team captain and MVP in both sports her senior year. She was a member of the 1982 NCAA champion lacrosse team, which finished with a perfect 10-0 record. (Courtesy of Media Relations.)

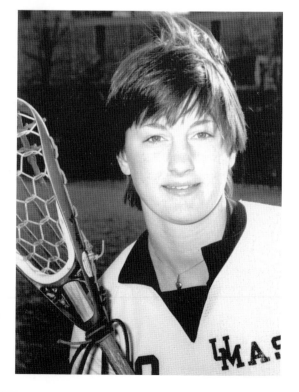

The first UMass men's soccer player to be inducted into the Hall of Fame, Granville Pruyne '33 was Massachusetts's first All-American selection in the sport, having earned recognition for his play as a forward for coach Lawrence Briggs's team in 1932. A member of Massachusetts's first three soccer teams in 1930, 1931, and 1932, Pruyne helped the Aggies to an 11-5-1 record. He was also a two-year letter winner in track (1932 and 1933), captaining the UMass team in 1933.

Michael Quinn '79 was a four-year member of the UMass cross-country and track and field teams from 1975 to 1979. He earned All-America honors in cross-country in both 1976 and 1977, and qualified for the NCAA championship five times in his career (three times in cross-country and twice for the 5,000 meters in outdoor track). A six-time All-Yankee Conference selection, Quinn captured individual cross-country titles at the league championship meets in 1976, 1977, and 1978. (Courtesy of Media Relations.)

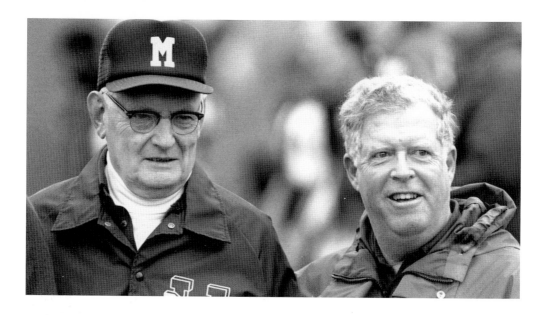

George Snook (left) and Dr. James Ralph are pictured on the sidelines during a football game in 1998. Ralph joined the University of Massachusetts Health Services in 1963 and started his 33-year career as team physician in 1964. As team physician, he worked primarily with the football and men's basketball teams but also worked closely with other sports, including women's basketball and men's and women's gymnastics. Ralph retired from service to the university in 1997. (Courtesy of Dr. James Ralph.)

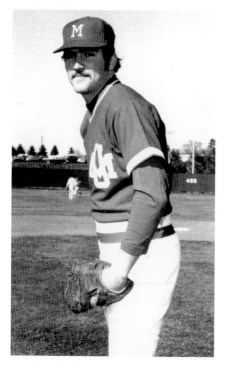

Jeff Reardon '78 lettered four times on the UMass baseball team from 1974 to 1977 and still holds the all-time UMass record for career strikeouts, with 234. He pitched 253 1/3 innings during his UMass career, setting a record that stood until the 1999 season. Reardon also led the team in strikeouts all four years and had the lowest ERA on the team as a freshman in 1974. He set a school record with 37 starts on the mound during his career, including 13 complete games, and led the team to a 24-13 record as a junior in 1976, setting a then team record for single season victories. Reardon went 5-3 with a 2.95 ERA as a senior in 1977 and was drafted by the New York Mets following the completion of the season. He went on to pitch 16 years in the major leagues with the Mets (1979–1981), Montreal Expos (1981–1986), Boston Red Sox (1990–1992), Atlanta Braves (1992), Cincinnati Reds (1993), and New York Yankees (1994). (Courtesy of Media Relations.)

A three-time letter winner in football, Noel Reebenacker '54 of Reading walked on to the team in 1951 as a quarterback. A Little All-American team selection in 1953, Reebenacker set school single-season records for yards (1,865), completed passes (132), touchdown passes (20), total offense (2,080), as well as the longest kickoff return in school history, a 102-yarder against Springfield College in 1951. (Courtesy of Media Relations.)

George Richason Jr. '37 has been part of the university community since the mid-1930s, earning a bachelor of science degree in chemistry in 1937 and his master of science degree in chemistry in 1939. Richason then went on to serve four years in the U.S. Navy during World War II. He returned to UMass in 1947 and has served as a faculty member ever since. In 1963, he was named the University of Massachusetts Distinguished Teacher of the Year and, in 1974, earned the Associate Alumni Award for Distinguished Service to the University. (Courtesy of Media Relations.)

Allyson Rioux '84 earned second-team All-America honors in 1983 as a shortstop for coach Elaine Sortino. A two-time All-New England shortstop (1981 and 1983), Rioux earned All-Atlantic 10 honors as a senior in 1984, when the Minutewomen won a then school-record 29 games. As a senior captain, she hit a team-high .372, led the team in doubles (6) and home runs (3) and RBIs (30), and ranked second in walks (15). She hit .301 as a junior in 1983 with 10 RBIs and 6 doubles. Rioux died of a brain tumor at age 27. She was inducted into the Hall of Fame in 2002. (Courtesy of Media Relations.)

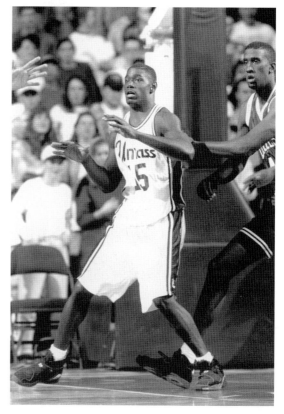

Lou Roe '95 was the first basketball player in school history to earn first-team All-America, getting named in 1995, the same year he was the A-10 Player of the Year. He was also named first-team A-10 three times between 1993 and 1995. Roe is UMass's all-time leading rebounder, with 1,070, and is the third all-time leading scorer, with 1,905 points. He led UMass to the NCAA tournament in all four seasons at UMass, including the Elite Eight as a senior. He finished his UMass career, averaging 14.2 points and eight rebounds, and shot 53 percent. Roe's numbers included 7.8 points and 6.4 rebounds as a freshman, 13.8 points and 9.2 rebounds as sophomore, 18.6 points and 8.3 rebounds as a junior, and 16.5 points and 8.1 rebounds as a senior. (Courtesy of Media Relations.)

Joe Rogers Jr. served as the swimming coach at UMass for 36 years, from 1935 to 1973. During that time, he compiled a career record of 152-149-1. He was also long recognized as one of the nation's leading authorities on pool construction and maintenance. Rogers joined the faculty of the university in 1930, and through his interest and tireless efforts, swimming became a varsity sport in 1935. Rogers also coached the UMass rifle team. (Courtesy of Media Relations.)

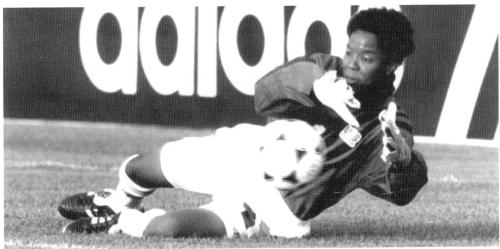

Brianna Scurry '93 was not only one of UMass's best soccer players ever but also one of the best players in the United States. She was named All-America in 1993 and was also the Adidas Goalkeeper of the Year. In her UMass career, she had 37 shutouts and goals against average (GAA) of 0.56. The shutout mark is second all-time and the GAA is fifth, and she is second in career saves, with 368. She won Olympic gold medals in 1996 and 2004. (Courtesy of Media Relations.)

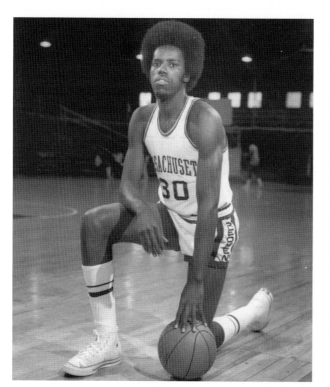

A three-time letter winner in basketball, Al Skinner '74 led the team in rebounding from 1972 to 1974, totaling 749 rebounds. He set a school record for highest career field goal percentage at UMass (.557), as well as in a single-season (.620)—records he held for nearly 20 years. He was a three-time first-team All-Yankee Conference selection and helped UMass to two Yankee Conference titles. He led the league in scoring in 1974, averaging 18.7 points per game. He was the eighth player in school history to join the 1,000-Point Club, finishing his career with 1,235 points. (Courtesy of Media Relations.)

Jeff Spooner '77 earned four letters in lacrosse from 1974 to 1977 under Hall of Fame coach Richard F. Garber. Spooner still ranks as the all-time leading scorer in UMass history, with 275 points. Spooner finished his career with then career records of 134 goals and 141 assists, marks that today rank fourth and second, respectively. A four-time All-New England selection, Spooner played on three New England championship teams (1974 and 1976–1977). (Courtesy of Media Relations.)

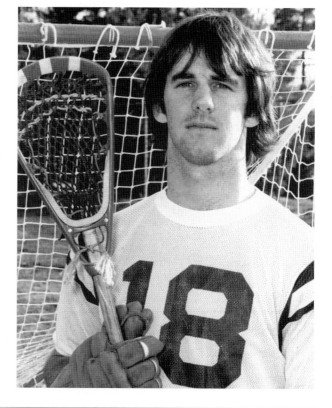

Shown from left to right, John Stewart '36, Lou Bush, and Joe Lojko sit on the bench together for their team photograph in 1934. All three of these men are in the UMass Hall of Fame. A three-sport athlete at UMass, John Stewart earned eight career letters. He won three letters in both football and basketball and two in baseball. He captained the 1936 basketball team and was a member of the 1934 team that went undefeated (12-0).

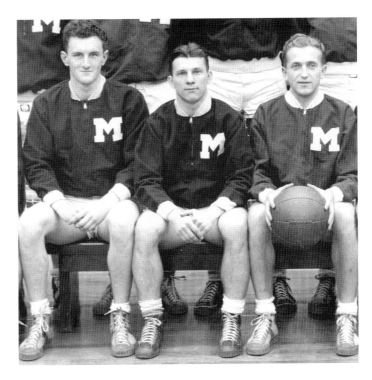

A two-sport athlete in field hockey and women's lacrosse, Judy Strong '81 competed at UMass from 1979 to 1981. A three-time Mitchell and Ness All-America selection in field hockey, Strong was the National Player of the Year in 1981. UMass's all-time leading scorer with 202 points, she was a member of the 1981 team that advanced to the national championship game, losing to the University of Connecticut 4-1. (Courtesy of Media Relations.)

Phillip Tarpey Jr. '55 earned UMass's first All-America award in baseball, being named third-team by the American Baseball Coaches Association in 1955. A member of two consecutive NCAA tournament teams (1954–1955), he helped UMass advance to the College World Series in 1954, the school's first ever appearance. In 1955, Tarpey was the MVP of the NCAA Regional, a member of the NCAA Regional All-Tournament team, and winner of the E. Joseph Thompson Memorial MVP Trophy (team MVP). (Courtesy of Media Relations.)

A four-time letter winner in both cross-country and track and field, John Thomas '75 competed at UMass from 1972 to 1975, captaining the team to four Yankee Conference championships, the 1973 New England title, and the 1974 IC4A championship. The IC4A title was the first by a New England school in over 30 years. He won seven Yankee Conference titles, winning the 1972 cross-county title, the one-mile from 1972 to 1974, and the two-mile from 1973 to 1975. (Courtesy of Media Relations.)

A two-sport athlete at UMass, Billy Tindall '68 competed for both the basketball team and the track and field squad from 1965 to 1968. A two-time All-Yankee Conference selection in basketball, Tindall led the conference in scoring, with a 22.7 points per game scoring average in 1968. As a track athlete, Tindall set Yankee Conference and UMass records outdoors in the triple jump in 1966 and 1967 and in the high jump in 1968. (Courtesy of Media Relations.)

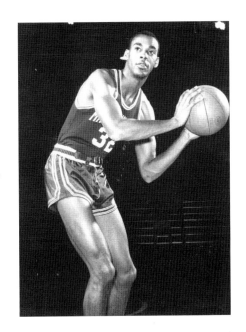

From left to right are Rodger Twitchell '64, coach Matt Zunic, and Peter Bernard. Twitchell was a three-year letterman in both basketball and tennis from 1961 to 1964. On the hardwood, Twitchell was a member of UMass's 1962 team, which captured the Yankee Conference title and advanced to the NCAA tournament for the first time ever. In tennis, Twitchell posted a career record of 24-1 in singles and 16-4 in doubles. (Courtesy of Media Relations.)

Anne Vexler '74 earned four letters as a member of the UMass women's gymnastics team from 1971 to 1974, earning All-America honors in 1973. She was a member of the 1973 team that captured the AIAW Intercollegiate Gymnastics national championship and tied for first in the all-around at the Eastern Regional in 1972. Vexler was a finalist on the balance beam at both Nationals and Easterns in 1972, with UMass finishing fourth as a team in the 1972 AIAW national championship.

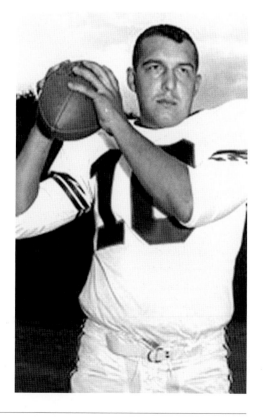

Jerry Whelchel '65 was the quarterback and team captain of one of UMass's most successful teams, the 1964 squad, which played in the Tangerine Bowl in Orlando, Florida. The team went 8-2, including a perfect 5-0 in winning the Yankee Conference. Whelchel was named UMass's MVP in the Tangerine Bowl. He was All-Yankee Conference in both 1963 and 1964 and won the Bulger Lowe Award as New England's top player in 1964. (Courtesy of Media Relations.)

COACHES, STAFF, BUILDINGS, AND FIELDS

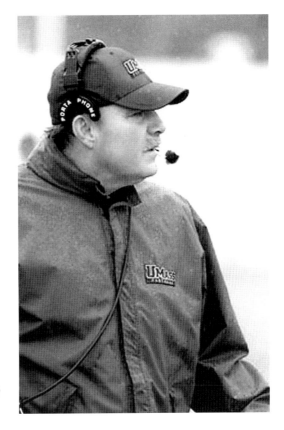

Coach Don Brown was the architect of the defense that led UMass to the 1998 national championship. Brown was named the 27th head coach in the 122-year history of the UMass football program on February 9, 2004. He returned to UMass after four seasons as head coach at Northeastern University. Recognized as one of the top defensive minds in Division I-AA football, he previously served as defensive coordinator for the Minutemen during the 1998 and 1999 seasons. (Courtesy of Media Relations.)

Elaine Sortino has served as the head coach of UMass women's softball for 26 seasons. She has posted a remarkable record of 858-372-3. On December 4, 2004, Sortino was inducted into the National Fastpitch Coaches Association Hall of Fame at its annual convention in Las Vegas, Nevada. Sortino has led UMass to 17 Atlantic 10 Conference titles, 14 NCAA regional appearances, and three trips to the NCAA College World Series. (Courtesy of Media Relations.)

John McCutcheon was named the sixth permanent athletic director at UMass on February 4, 2004. He oversees and directs all operations for UMass's 23 sports and athletic support services. McCutcheon came to UMass from California Polytechnic State University, where he was the director of athletics for a 20-sport varsity program from 1992 to 2004. (Courtesy of Media Relations.)

UMass head basketball coach Travis Ford and his mentor, coach Rick Pitino '74, confer during a game. Ford played basketball for Pitino at the University of Kentucky from 1991 to 1994. When Ford was hired to lead the Minuteman basketball team on March 25, 2005, his former coach, Pitino, had this to say: "Travis Ford is one of the brightest players I have coached in 30 years. . . . I could not be happier for my alma mater." (Courtesy of Media Relations.)

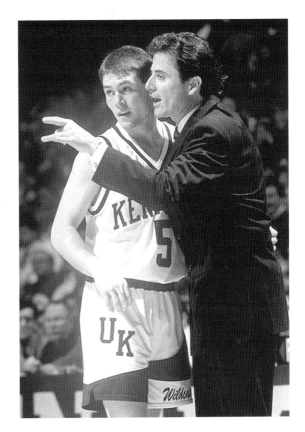

Don "Toot" Cahoon has coached the Minuteman hockey team since the 2000–2001 season. As a player, Cahoon was a standout at Boston University, where he was an instrumental part of the NCAA Frozen Four championship victories of 1971 and 1972. He went on to serve as head coach for Lehigh University (1973–1974), Norwich University (1979–1982), and Princeton University (1991–2000). He was named Hockey East Coach of the Year and the New England Hockey Writers Association Coach of the Year in 2003. (Courtesy of Media Relations.)

Coach Jack Canniff was appointed head coach of the men's varsity ice hockey program in April 1967. Canniff was a tremendous hockey player at Boston College from 1952 to 1954. He spent two years in the army before he took the reins of Gloucester High School, where he coached for 11 years. He won the esteemed Edward Jeremiah Award in 1972 as the Division II Coach of the Year. The Edward Jeremiah Award is named after the famed Dartmouth College coach. Canniff coached the UMass hockey team from 1967 to 1979. (Courtesy of Media Relations.)

Jim Rudy has been coaching women's soccer at UMass since 1988. At the beginning of the 2005 campaign, he had an impressive record of 205 wins, 107 losses, and 16 ties at UMass. Among NCAA Division I women's soccer coaches, Rudy ranks third all-time, with 268 career wins (22 at Central Florida). (Courtesy of Media Relations.)

Jim Dietz has been at the helm of the women's crew team since 1994. Dietz is the only crew coach in UMass history; his teams won nine straight Atlantic 10 titles through 2004. In his 11 seasons, Dietz was named Coach of the Year six times. He coached the 1998, 1992, and 2000 U.S. Olympic teams and was a member of the 1972, 1976, and 1980 U.S. Olympic teams. (Courtesy of Media Relations.)

Coach Ken O'Brien '63 has been coaching UMass track and cross-country since 1968. Under the tutelage of O'Brien, the Minutemen have won 18 conference titles, four New England crowns, and two IC4A titles and have produced seven All-America performers. While an undergraduate at UMass, O'Brien won six letters in cross-country and track. (Courtesy of Media Relations.)

Russ Yarworth '78 is in his 26th season as head coach of the UMass men's swimming and diving program. As coach, Yarworth has won seven Atlantic 10 championships and eight New England championships. He has six undefeated seasons, six Atlantic 10 Coach of the Year awards, eight Eastern championships in water polo, and four Water Polo Eastern Coach of the Year Awards. (Courtesy of Media Relations.)

Glenn Wong has been a professor in the sports management department since 1979. Wong currently serves as faculty athletics representative and has served in many other capacities, such as interim athletic director, head of the sports management department, and dean of the School of Physical Education. Wong has been awarded the Chancellor's Medal and the Alumni Association Distinguished Faculty Award. He is one of the most respected sports minds at the University of Massachusetts Amherst. (Courtesy of Media Relations.)

Richard P. Halgin, professor of psychology, joined the UMass faculty in 1977. Since the reintroduction of varsity hockey in 1993, Halgin has served as an adviser to the program. In his role as a faculty member, he has assisted team members in their efforts to obtain an excellent education at the university and has sponsored a number of student-athletes for internships, independent study projects, and individualized majors—bachelor's degree with individual concentration (BDIC).

Curry S. Hicks served as the athletic director of the University of Massachusetts from 1911 to 1948. He came to Massachusetts Agricultural College in 1911 from Michigan State Normal School. The Physical Education Building was named the Curry Starr Hicks Physical Education Building in 1941. (Courtesy of Special Collections and University Archives, W. E. B. Du Bois Library.)

In 1914, the grading and draining of the new athletic field began. The field (upper left) was located where both Herter Hall and the Whitmore Administration Building now sit. The baseball and football team used the field until the mid-1960s. (Courtesy of Special Collections and University Archives, W. E. B. Du Bois Library.)

The William D. Mullins Center was opened in February of 1993. William D. Mullins, a state representative from Ludlow, was responsible for securing the funds to build the $52 million facility.

Home of Garber's Gorrillas, Richard F. Garber Field was dedicated in 1992 to Dick Garber, who coached the UMass lacrosse team from 1955 to 1990.

Warren G. McGuirk Alumni Stadium opened on September 25, 1965, as Alumni Stadium, with the Redmen beating American International College 41-0. On December 3, 1984, nearly 20 years after its opening, the stadium was named after Warren G. McGuirk, the athletic director from 1948 to 1971. (Courtesy of Special Collections and University Archives, W. E. B. Du Bois Library.)

On June 13, 1931, Pres. Roscoe W. Thatcher dedicated the new physical education building. The architect was Clinton F. Goodwin of the MAC class of 1916. In 1941, the physical education building was named the Curry Starr Hicks Building. The new building served as the center of a complete indoor and outdoor physical education program for the entire college year. The building and its equipment were provided at a cost of $287,500. The Massachusetts State Legislature of 1930 appropriated $172,500 for the construction of the building. Alumni from as far back as the first class of 1871 generously donated the remaining sum. (Courtesy of Special Collections and University Archives, W. E. B. Du Bois Library.)

Equipment manager Tom Bishko puts the finishing touches on a football helmet in 1979.

(Courtesy of Media Relations.)

These two men had the unenviable task of cleaning the day's laundry for the sports teams in 1965. Workers such as these kept the athletic programs moving forward. (Courtesy of Media Relations.)

These three men are representative of all of the university staff members who have worked so hard over the years for the athletic programs. The words on the tractor read, "Mr. Phy. Ed." and "We move the earth." (Courtesy of Media Relations.)

ACKNOWLEDGMENTS

This book was a challenge to write. I spent countless hours combing over statistics, newspaper articles, yearbooks, and media guides. I had many long interviews with faculty, staff, and coaches. With only 128 pages to work with, and a maximum of 80 words per caption, I had to make some hard choices as to which photographs would be published and which ones would not. I have done my best to capture the rich history of athletics at the University of Massachusetts Amherst. A very special thank-you goes to Robert Cox and Mike Milewski of the W. E. B. Du Bois Library Special Collections and University Archives. They were very patient and supportive during the research stage of this publication. I would also like to thank the Media Relations team for its unswerving support.

I also wish to thank the following for much appreciated guidance and support during this project: the UMass Amherst Alumni Association, Bob Behler, Thorr Bjorn, Jeff Bohne, Don Cahoon, coach Jack Canniff, Harold Whiting Cary, Robert Cox, Elizabeth Dale '86 G '98 Ed.D., Tom "TD" Dougherty '84, Ruthie Drew, Jeff Earls '06, Paul "Good Fitz" Fitzpatrick, Kimberly Gardner, Red Gendron, Seth Gerard, Jason Germain, Cristina Geso, Robert Goodhue '70,

Tiffany Howe, Lisa Kennedy, Tim Kenney, Hal Lane Jr. '60, Chancellor John V. Lombardi, Deb Masloski, C. J. Masse, John McCutcheon, Michael Milewski '77, Len Quesnelle, Dr. James Ralph, Frank Prentice Rand, Media Relations, J. Anthony Roberts, Jon Sinnett, Alec Sullivan, Eliza Sullivan, Suzanne Sullivan, Teamsters Local 25, Dominique Tremblay, Liz Unterman, W. E. B. Du Bois Library Special Collections and University Archives, Karen Winger, and Jason Yellin.

Steven R. Sullivan '91 is the secretary of the UMass Hockey Pond Club, the nonprofit fund-raising and marketing arm of the men's hockey team.